STANDARD BOOK OF

HERMÈS
PARIS

Chloé Kamali-Worth

Copyright © 2024
All rights reserved. No part of this publication may be reproduced, distributed or transmitted in any form or by any means, including photocopying, recording, or other electronic or mechanical methods, without the prior written permission of the publisher, except in the case of brief quotations embodied in reviews and certain other non-commercial uses permitted by copyright law. Any references to historical events, real people or real places may be real or used fictitiously to respect anonymity. Names, characters and places may be the product of the author's imagination.

STANDARD BOOK OF

HERMÈS
PARIS
1837

CHLOE KAMALI-WORTH

Thierry Hermès was born in 1801 in Krefeld, Germany, to a family of French origin. In 1828, he moved to Paris where he founded the Maison Hermès in 1837. Initially specializing in the manufacture of high quality harnesses and saddles for the European aristocracy, the Hermès company quickly established itself as a reference in the world luxury equestrian equipment. Thierry Hermès was able to exploit his exceptional artisanal know-how to create durable and elegant products, which quickly won the favor of the noble clientele of the time.

Thierry Hermès has acquired a reputation for excellence, contributing significantly to the growth of the luxury industry in France. After the death of Thierry Hermès in 1878, his descendants continued to develop and diversify the company, entering the field of fashion accessories, perfumes and ready-to-wear items.

The codes of Hermès luxury

Excellent craftsmanship: Hermès highlights its meticulous artisanal know-how, with particular attention to detail and quality. Each product is handcrafted by highly skilled artisans, using traditional techniques passed down from generation to generation. This guarantees impeccable quality and exceptional durability of the products.

High-quality materials: The use of luxurious materials, such as calfskin, crocodile, ostrich, and silk, is a central pillar of Hermès designs. These materials are carefully selected and processed to ensure the highest possible quality, contributing to the brand's worldwide reputation in leather goods and silk squares.

Exclusivity and rarity: Hermès is famous for its exclusivity. Products such as Birkin and Kelly bags are often produced in limited quantities and can require waiting lists of several years. This rarity and the difficult acquisition process reinforce the luxury status and desirability of the brand.

Timeless Design: Hermès designs are often clean, elegant and timeless, eschewing fleeting fashion trends to focus on style that transcends the seasons. Their designs are intended to be worn for many years, even decades, reflecting an investment in quality rather than passing fashion.

Discretion in branding: Unlike some luxury brands which use their logos extensively, Hermès is known for its discretion. Logos are subtly incorporated into the designs, allowing the quality materials and craftsmanship to speak for themselves.

Heritage and tradition: The rich history and connection to horse riding is often evoked in Hermès products, from its silk scarves with equestrian motifs to its bags named after icons or historical figures.

> **In each Hermès silk thread, dances the secret of luxury.**
>
> *Thierry Hermès*

The history of the Hermès house, from 1837 to today

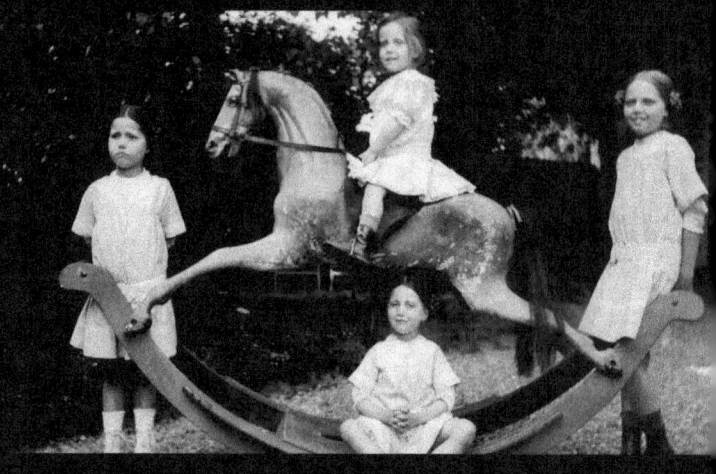

The four daughters of Émile Hermès on the family rocking horse. Jacqueline (left), Aline (on the horse), Simone (in front) and Yvonne. Photograph taken in 1912 by their mother, Julie Hermès, whose maternal family owned this pretty and tireless mount.
Hermès Archives, Paris

Since its founding in 1837, Hermès has embodied the convergence of meticulous craftsmanship and adaptation to the lifestyles of its customers. Each generation has carried this heritage with a spirit of freedom and creation that has never failed. Hermès has always shown particular sensitivity to social changes and emerging needs.

The history of Hermès began in Paris in 1837, when Thierry Hermès opened his harness workshop on rue Basse-du-Rempart. From his first steps, he grasps and responds to the needs of his clients, seeking to combine lightness and elegance with the robustness of his creations, in the full effervescence of Parisian modernity. His harnesses, both discreet and durable, earned him recognition at the Universal Exhibition of Art and Industry in Paris in 1867.

During the interwar period, a period marked by profound changes in lifestyles, Émile Hermès, the son of Charles-Émile, took the reins of the Hermès house and breathed a breath of innovation. Initially focused on saddlery and harness, the brand then moved towards leather goods to meet society's new expectations. During a trip to Canada, a simple but ingenious invention caught his attention: a closing mechanism used on a military car hood, known as the American "closer". Seduced by this system, Émile Hermès secured its exclusivity in 1922, transforming what would become famous under the name of "zip closure", now widely used on Hermès luggage.

Throughout his life, Émile Hermès also devoted an intense passion to collecting works of art, books, and various objects, constituting a rich and eclectic collection. This collection, continually enriched by his descendants, remains a vital source of inspiration for the creations of the house of Hermès.

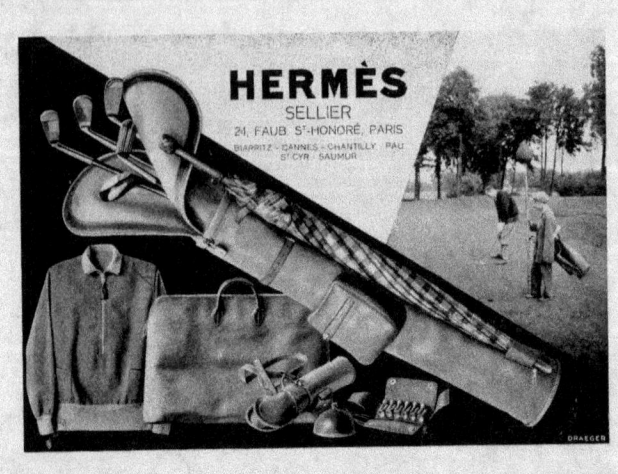

In 1925, under the direction of Émile Hermès, attached to its roots while resolutely turned towards its times, the Hermès house ventured into new areas. That year marked the launch of the brand's first men's garment: a golf jacket. Continuing this expansion, Hermès enriched its collection with the introduction of jewelry in 1927, followed by watches and sandals in 1928, thus expanding its offering to elegantly complement its customers' wardrobe.

1937 First silk scarf

With Jeu des omnibus et dames blanche, the famous silk square was born, the first model in a long series.

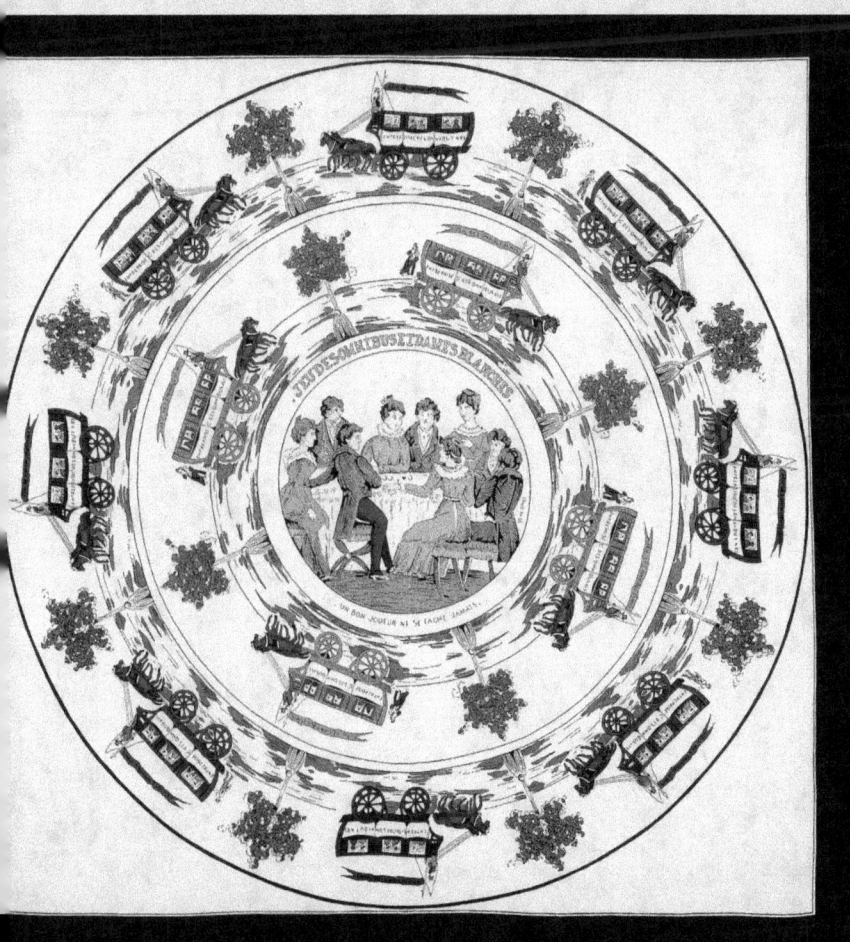

Today

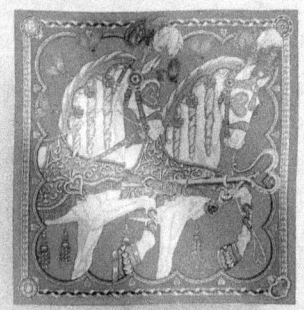

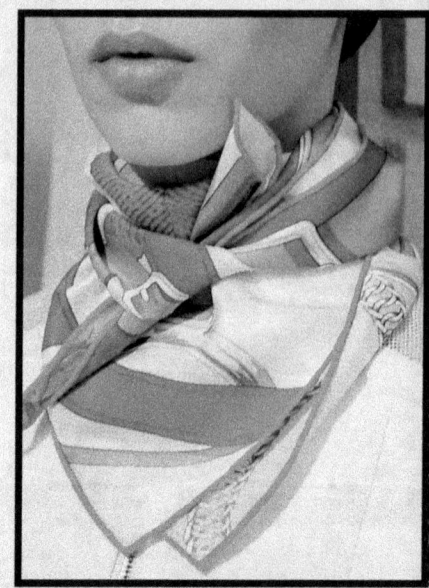

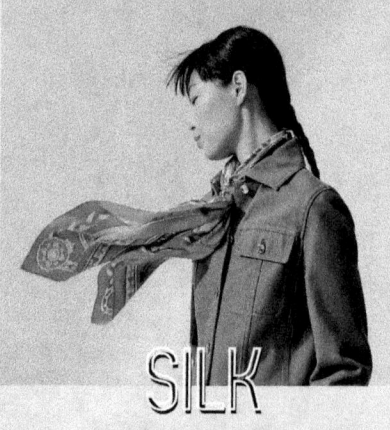

SILK

Hand-rolled 100% silk twill square.

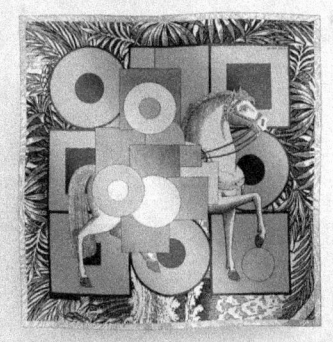

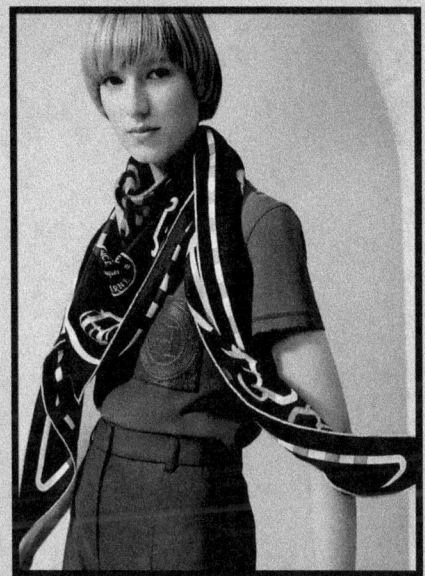

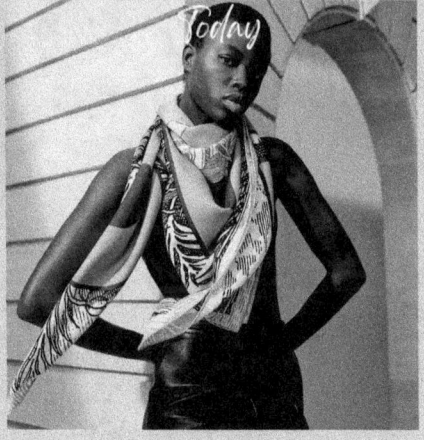

Today

Giant triangle 70% cashmere 30% silk rolled by hand.

hermes.com

In 1951

the management of Hermès passed to Robert Dumas

In 1951, management of Hermès passed to Robert Dumas, one of the sons-in-law of Émile Hermès, who only had daughters. Taking over in such a family business marks a turning point, and under his management, Hermès experienced several notable innovations. It was he who introduced the brand's first silk scarf, conceived the initial design of the future Kelly bag, and created the Chaîne d'ancre bracelet, inspired by the boats he observed in Normandy. These creations will become iconic and will contribute greatly to the prestige and continued success of Hermès.

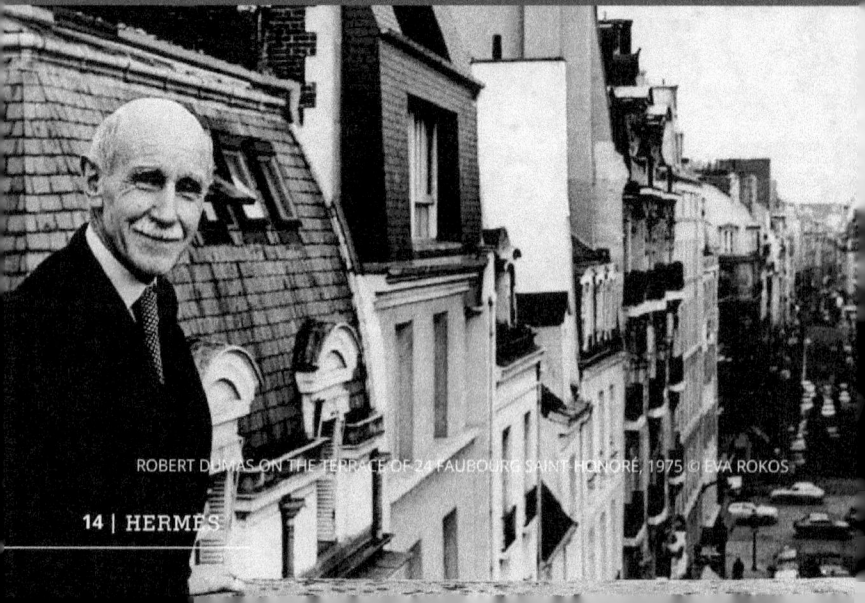

ROBERT DUMAS ON THE TERRACE OF 24 FAUBOURG SAINT-HONORÉ, 1975 © EVA ROKOS

1930

"The Kelly Bag: From Classic Elegance to Global Icon"

Originally designed by Robert Dumas in the 1930s, the handbag that would become famous met a watershed moment in 1956. That year, a photo of Grace Kelly using the bag spread across the globe, capturing the admiration of the audience. Recognizing her impact and the connection with the Princess of Monaco, Hermès decided to rename the bag in her honor, naming it "Kelly". This move marks the beginning of an era of international fame for this model, establishing the Kelly bag as a global luxury staple.

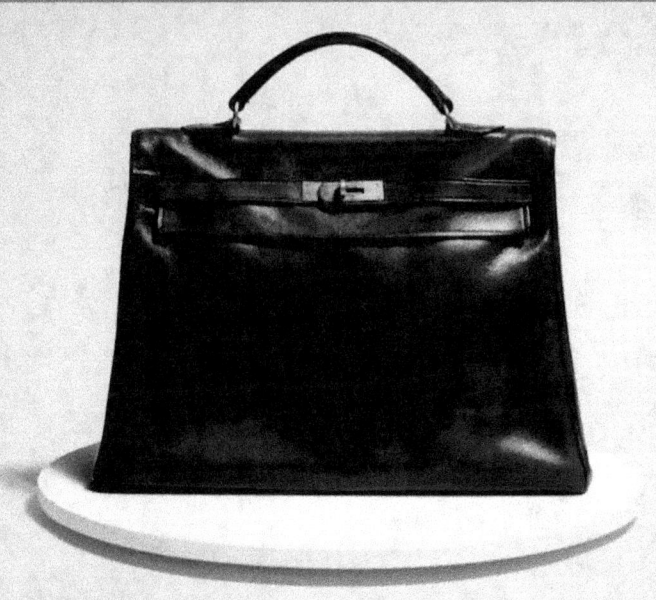

HERMÈS

Today

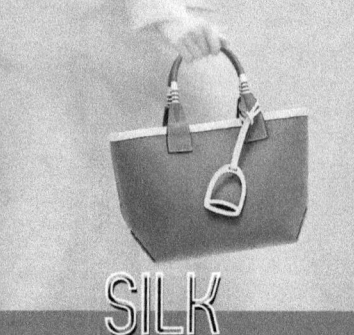

SILK

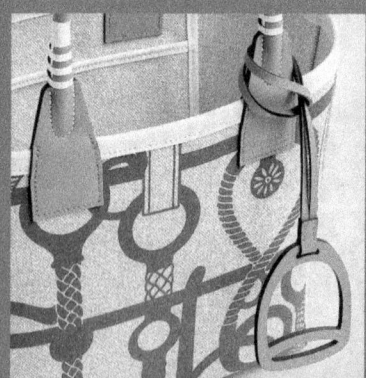

Hand-rolled 100% silk twill square.

www.hermes.com

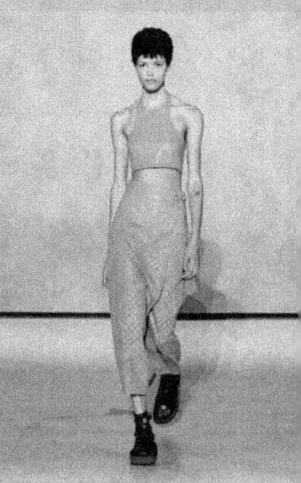

01

Hermès spring-summer 2022 show

The house chose to present its collection in the intimate and minimalist setting of the Mobilier National in Paris. This choice of location reflects Hermès' commitment to highlighting French craftsmanship and heritage, offering a sober and elegant setting that perfectly complements the refined aesthetic of the collection. The presentation highlighted neutral tones and simple cuts, emphasizing the understated sophistication that characterizes the brand.

> **For me, it's really about clothes that allow you to move freely. I think it's not about going to something too casual - I think it's about making an effort, but also being able to move in your clothes**

Nadège Vanhee-Cybulski artistic director of Hermès

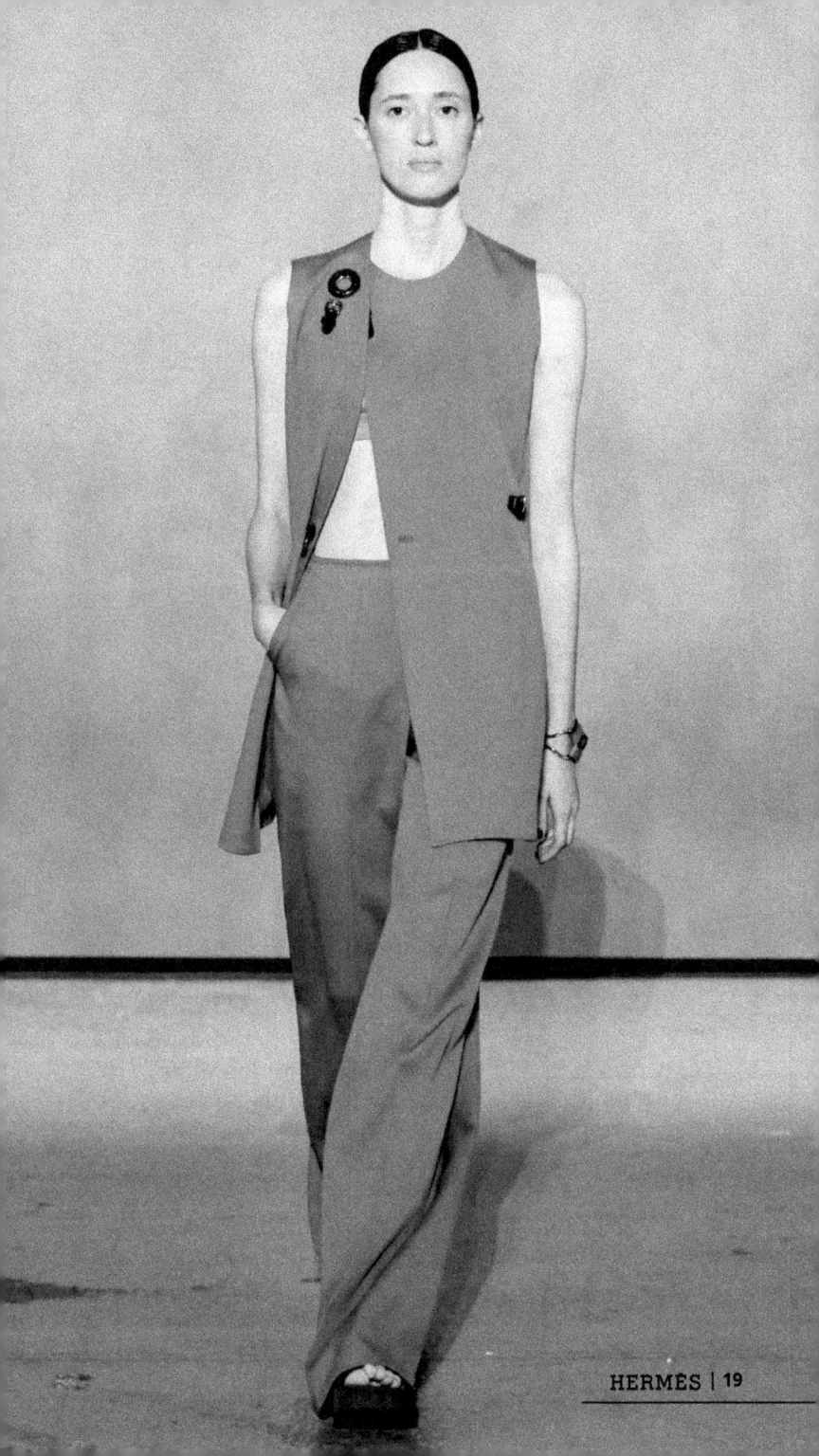

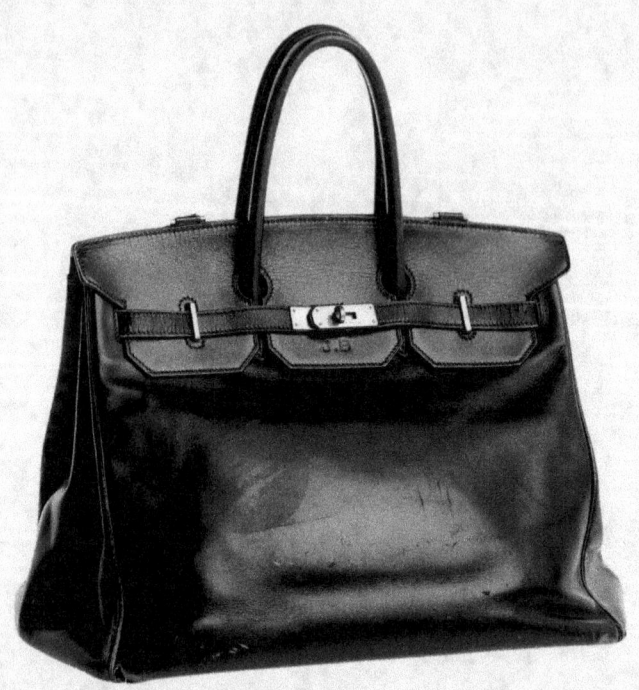

02

the introduction of the Birkin bag in 1984, resulting from a chance meeting between Jean-Louis Dumas, the president of Hermès at the time, and actress Jane Birkin. On a flight from Paris to London, **Jane Birkin expressed to Jean-Louis Dumas her inability to find a travel bag that was both spacious and elegant.** Inspired by this conversation, Dumas created a bag especially for her, which would become one of the most iconic and desirable handbags in the world, the ultimate symbol of luxury and exclusivity.

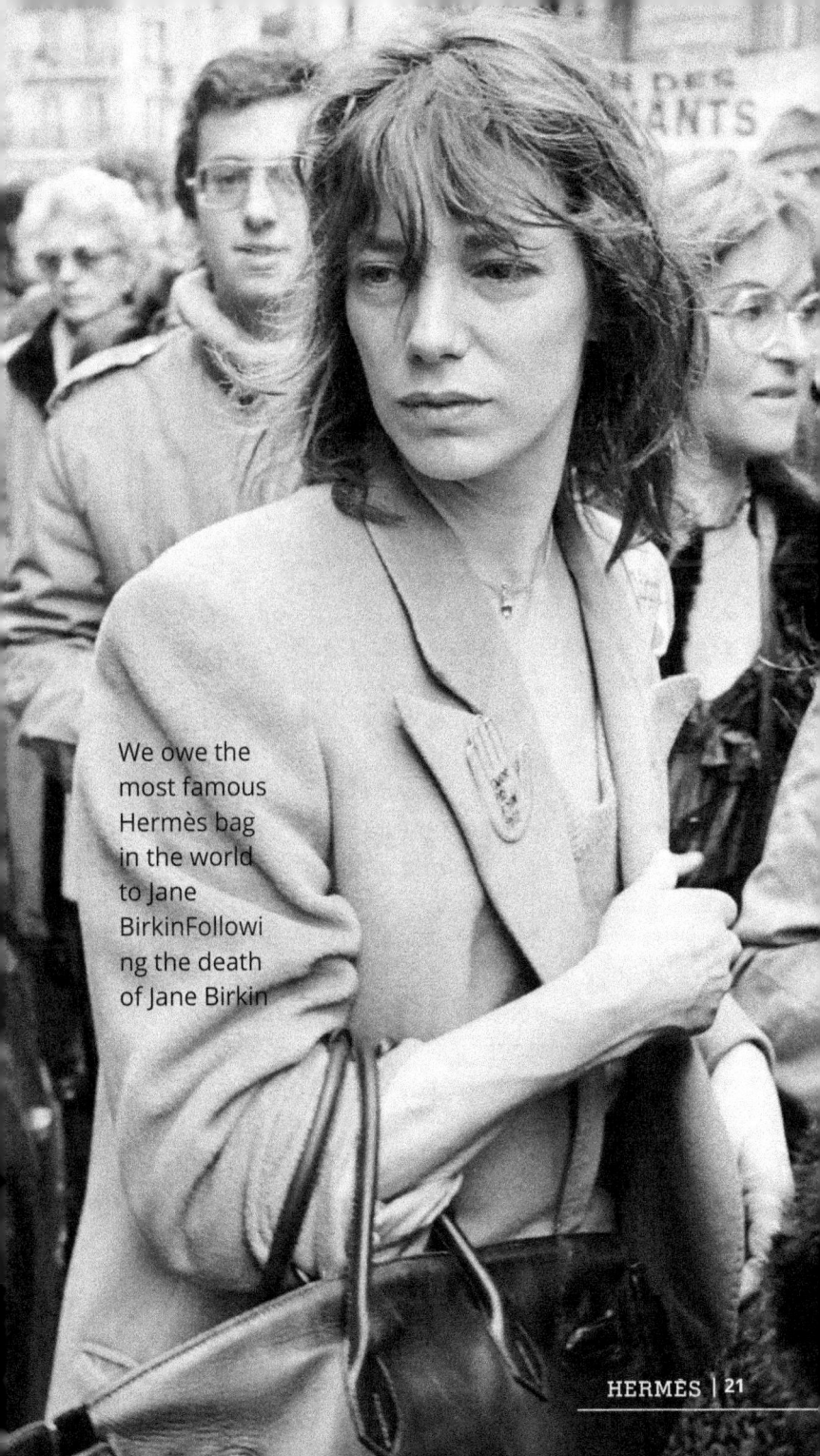

We owe the most famous Hermès bag in the world to Jane Birkin Following the death of Jane Birkin

The story of the Hermès Birkin bag

When **Jane Birkin's things spilled out of her bag onto the floor**, Jean-Louis Dumas suggested, "You should have one with pockets." » To which she replied, with her characteristic panache, **"The day Hermès makes one with pockets, I will adopt it."** » It was then that Jean-Louis Dumas revealed himself by telling him: **"But I am Hermes.** » The young mother, who had recently become the mother of Charlotte Gainsbourg, seized the opportunity and asked him why he could not create a bag four times larger than the Kelly, but smaller than Serge Gainsbourg's emblematic suitcase. Jane Birkin then sketched an improvised prototype on a vomit bag, and that's how the idea for the Birkin bag came to life.

This vision was followed by several meetings which resulted in the creation of a model meeting all the star's expectations. At the request of Jean-Louis Dumas, she agreed to have the bag bear his name. Initially made of soft black leather, it has been available over the years in several sizes, materials and colors. All its variants have met with the same success. During the Hermès fall/winter 2012-2013 fashion show, Birkin told Vogue US:

"

Now, when I go to sing in America, people ask me: Birkin? Like the bag? I answer: 'Exactly: and now the bag will sing.'

Jane Birkin

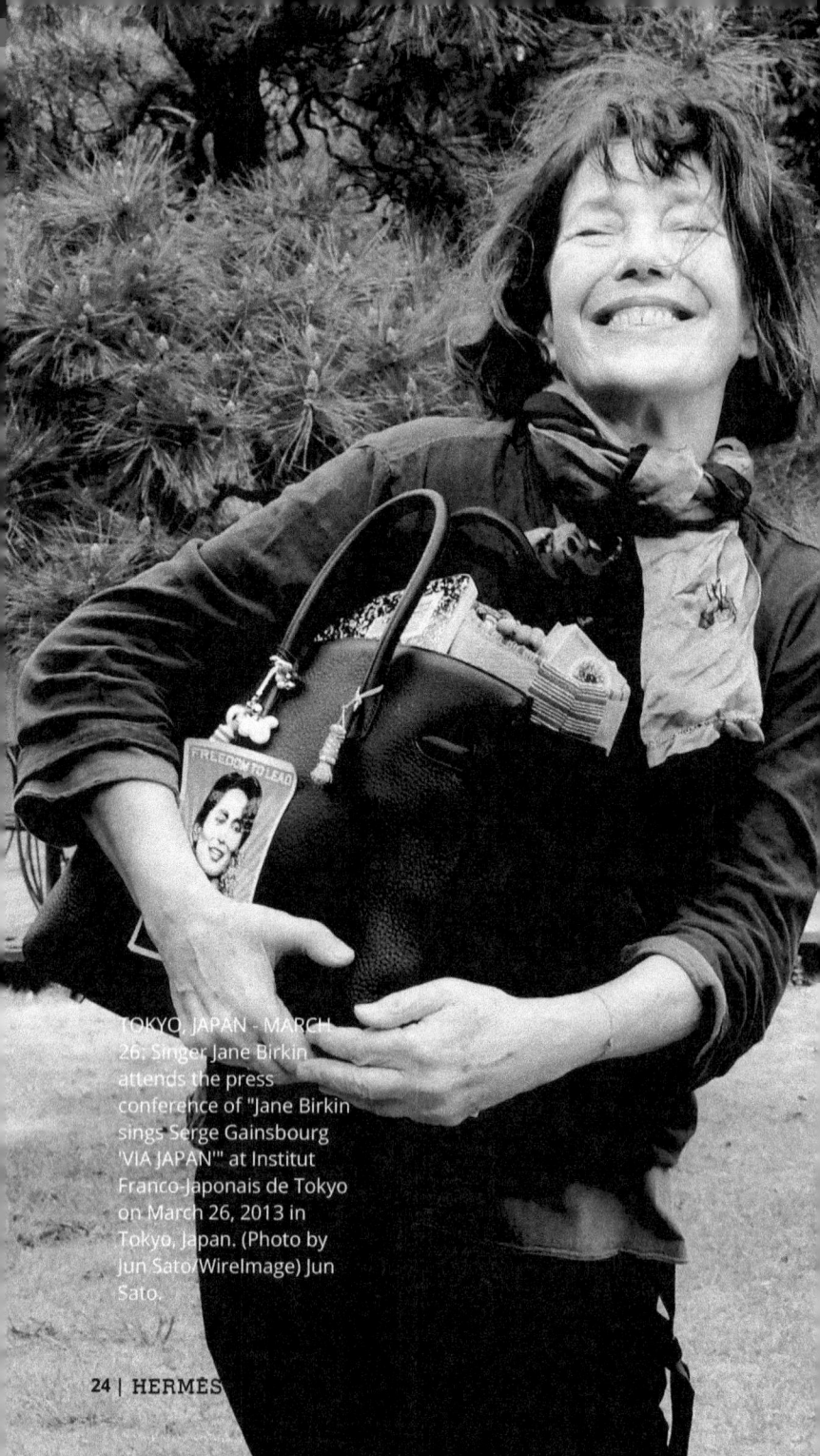

TOKYO, JAPAN - MARCH 26: Singer Jane Birkin attends the press conference of "Jane Birkin sings Serge Gainsbourg 'VIA JAPAN'" at Institut Franco-Japonais de Tokyo on March 26, 2013 in Tokyo, Japan. (Photo by Jun Sato/WireImage) Jun Sato.

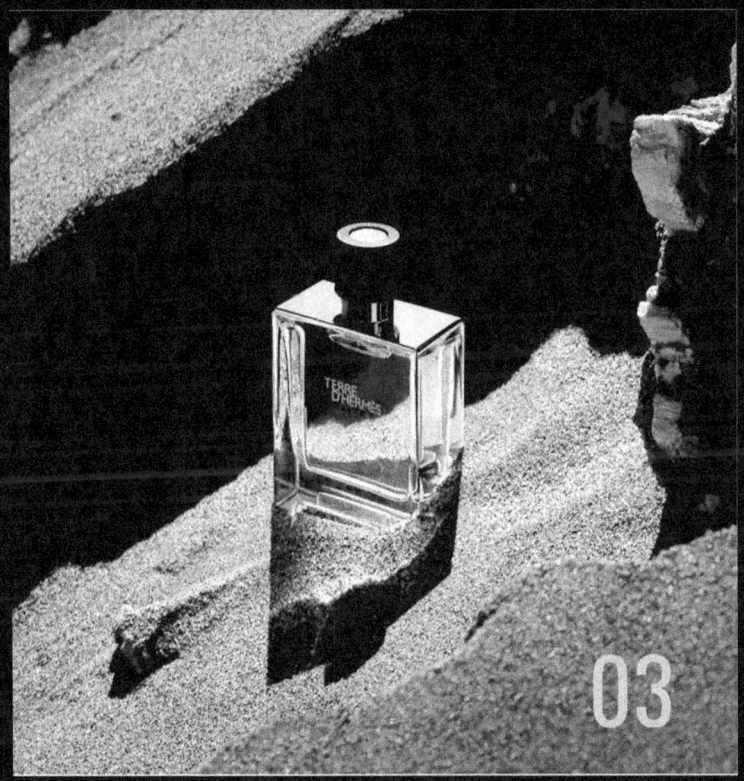

"Terre d'Hermès" created in 2006. This perfume is a creation of the famous perfumer Jean-Claude Ellena, known for his ability to capture the essence of nature in his fragrances. "Terre d'Hermès" stands out for its notes of earth and minerals, mixed with touches of orange and grapefruit, creating a scent that evokes the freshness of citrus fruits on a robust earthy background. This fragrance is designed to evoke the image of a journey through nature, capturing both the power and poetry of the earth. The success of "Terre d'Hermès" is based on its originality and its innovative approach to perfumery, making it one of the signature fragrances of the house of Hermès.

TRENDY INSPIRATIONAL OUTFIT OF THE DAY

HERMÈS PARIS

CHOOSE A HERMES STYLISH LOOK

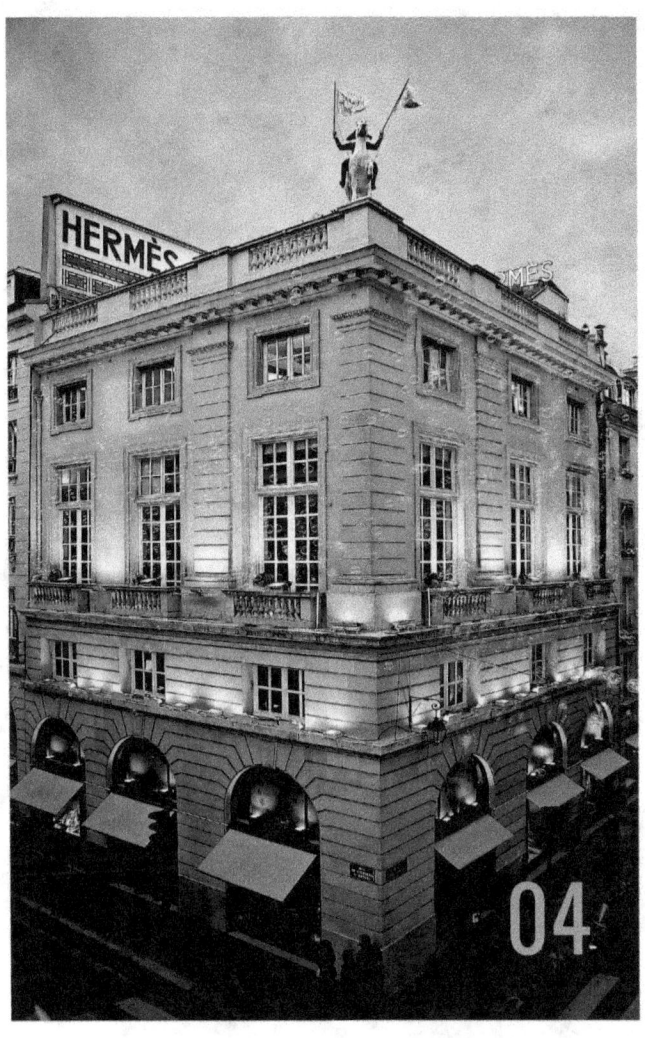

The Hermès Museum in Paris offers a captivating journey through the history of the house, displaying treasures of craftsmanship, iconic creations and archives that illustrate the rich heritage and continued innovation of this iconic luxury brand.

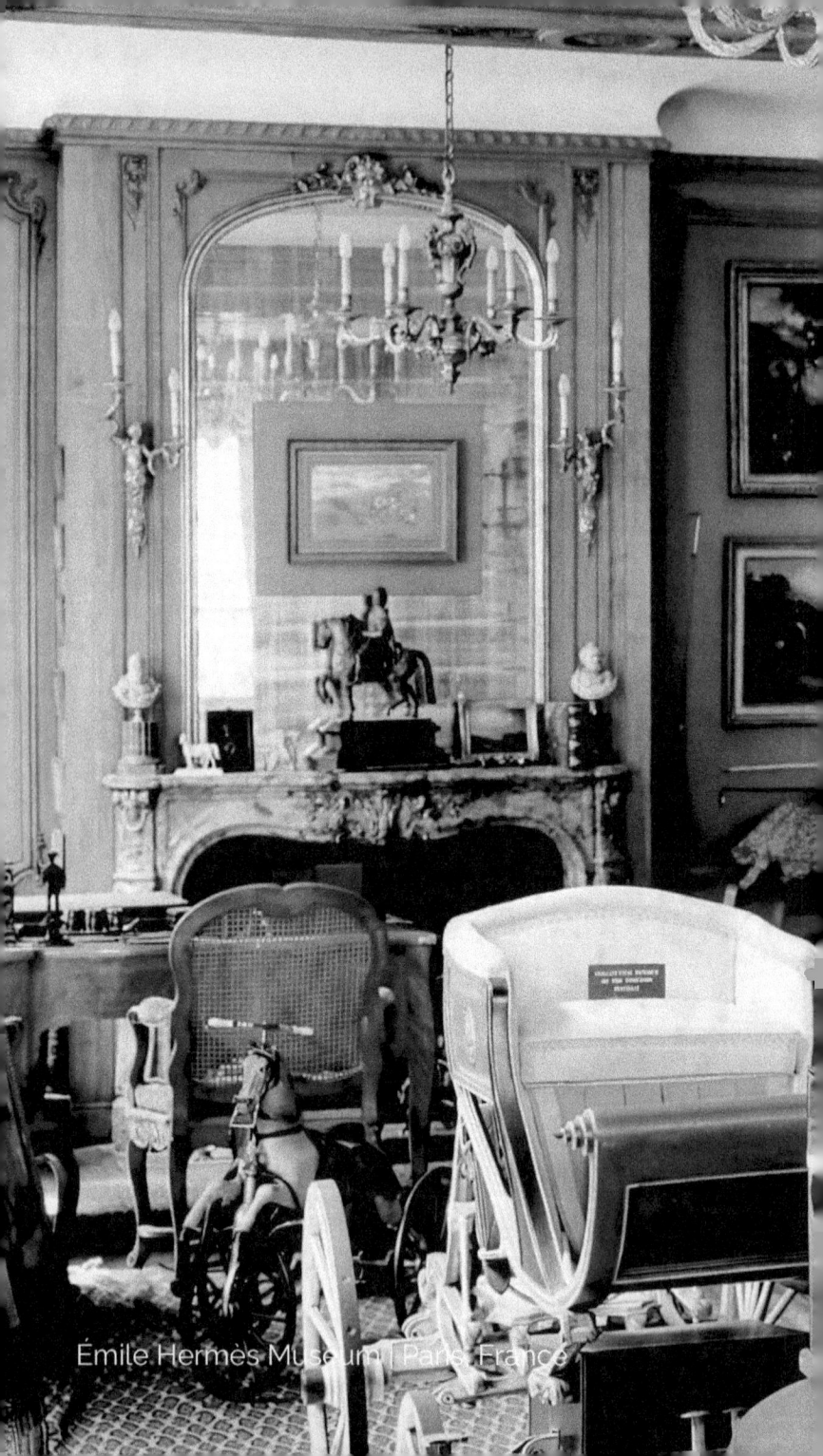

The discreet third floor of 24, rue du Faubourg-Saint-Honoré in Paris houses a little-known treasure: the Hermès cabinet of curiosities. Created almost a century ago by Émile-Maurice Hermès, this unique space contains an impressive collection dedicated to equestrianism, with works by artisans from the Belle Époque. Despite the proximity of the famous Hermès boutique, many visitors pass by this attic of elegance without knowing it, a place which celebrates two centuries of family heritage and creativity.

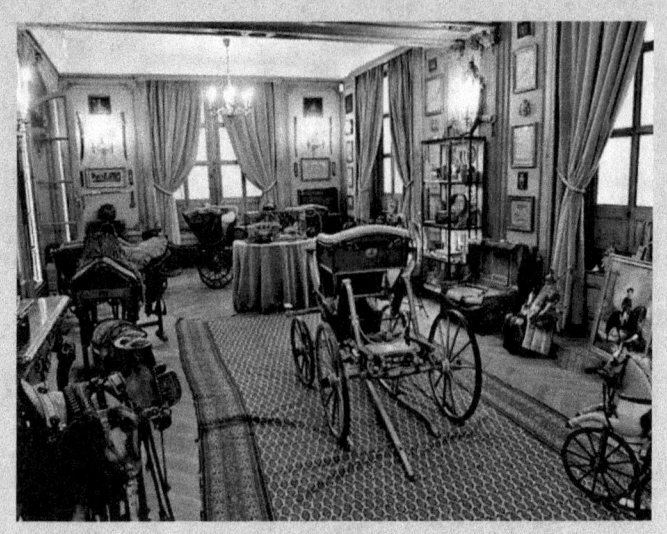

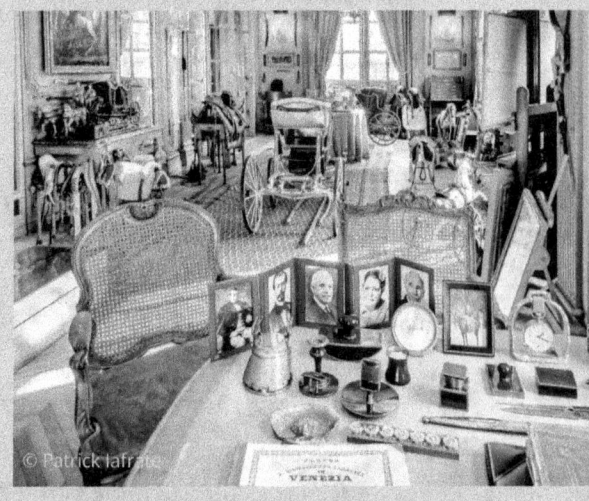

The study of Emile Hermès, passionate collector. The horse and the journey had a special place

The Hermès house watches over an exceptional collection, mainly devoted to horses, at its home in Paris. Inseparable from its creator, Emile Hermès, it inspires all the professions of the famous saddler.

Contemporary artisan since 1837

As an independent and responsible family business, Hermès maintains most of its production in France, spread across its 54 manufacturing sites.

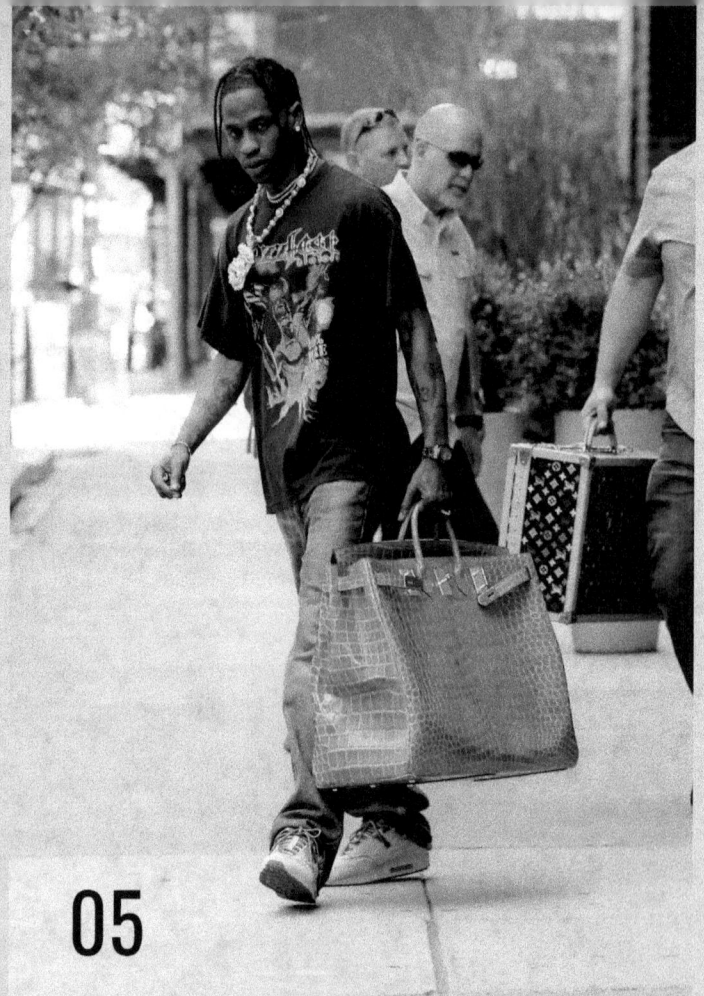

05

The ultimate luxury ?

Travis Scott's gigantic Hermès bag.
You could fit your laptop and chargers, your
clothes for the week, and even several puppies.

the belts •⊱——∘○∘——⊰• **Best style**

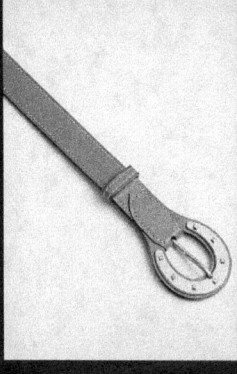

Hermes

THE BELTS

THE FASHION

with their characteristic "H" shaped buckle, are much more than just accessories. They embody a meeting between functionality and refinement, a distinctive symbol of the Hermès house which has transcended the boundaries of simple utility to become a true fashion statement. First introduced in the 1960s, Hermès belts feature a buckle that can be gold, silver or palladium

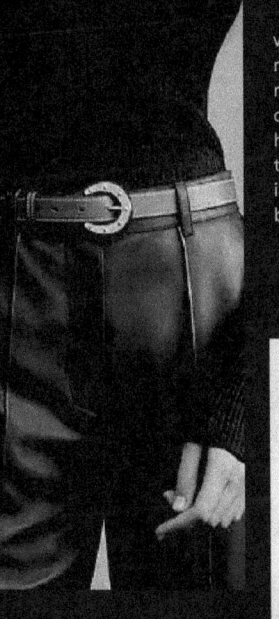

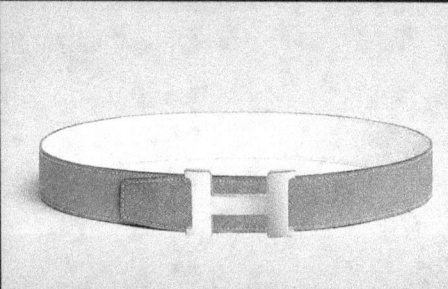

The brand introduced the concept of ready-to-wear luxury and pioneered the use of **androgynous looks**, profoundly influencing contemporary fashion trends.

SPRING SUMMER 24 LOOKS

06

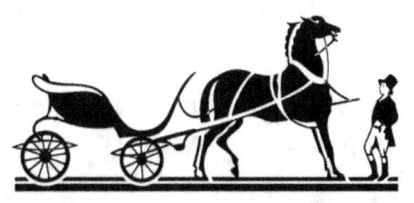

HERMÈS
PARIS

07

the origin of its logo

the harnessed duke, which was introduced in 1950. The logo depicts a harnessed duke, designed by Alfred de Dreux, and a groom, and has become synonymous with the brand. This logo perfectly illustrates the equestrian roots of Hermès, which began in 1837 as a manufacturer of high-quality harnesses and saddles for European nobility. This historic and recognizable symbol embodies the elegance and quality that continue to define the Hermès brand today.

Equestrian Elegance: The Heritage of Hermès Rider Boots

Hermès riding boots symbolize a deep connection with the equestrian origins of the house, which dates back to its founding in 1837 by Thierry Hermès. Initially recognized for its mastery in manufacturing high-quality harnesses and saddles for European aristocracy, Hermès' natural transition into equestrian fashion items has allowed the brand to maintain a reputation for excellence. Hermès riding boots are a perfect illustration of this heritage, combining functionality, comfort and elegance. Handcrafted by expert artisans, these boots are designed to deliver performance and durability, meeting the rigorous demands of equestrian sport while remaining true to the brand's refined aesthetic.

Over the years, **Hermès has been able to innovate while preserving traditional know-how in the design of its riding boots.** Using the highest quality leathers, each pair is the result of a meticulous process that can take several weeks. The careful design and precise finishes ensure not only optimal comfort but also a perfect adaptation to the rider's body shape. Available in several models, Hermès boots are aimed at a diverse clientele, from dressage enthusiasts to show jumping enthusiasts. These boots are not just sports equipment; **they have become symbols of luxury**, often worn as a fashion statement well beyond the equestrian trails.

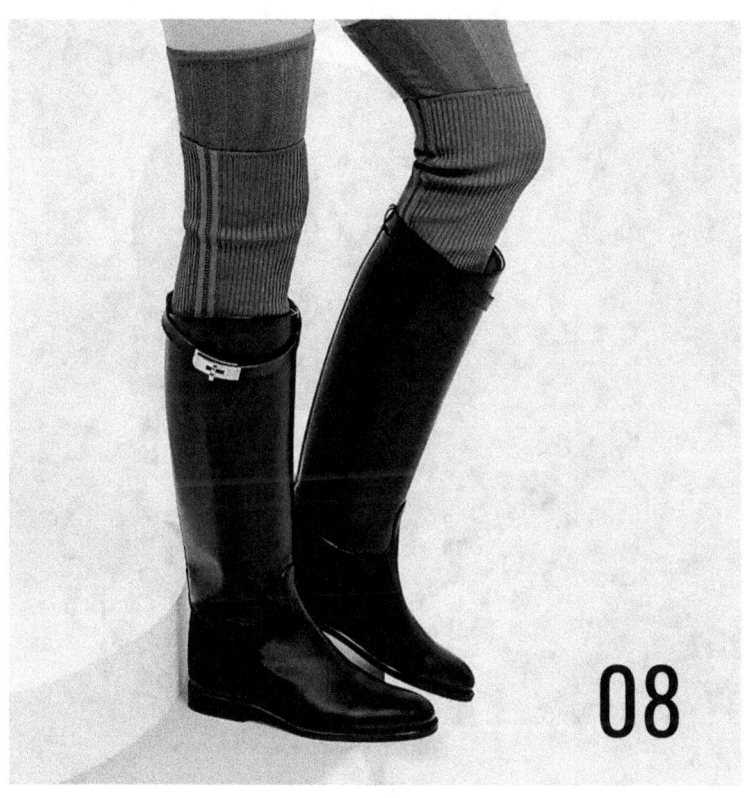

08

Among notable admirers, **Queen Elizabeth II** has been seen wearing Hermès boots during her public equestrian appearances. This royal preference is not only a testament to the superior quality and comfort of the boots, but also to their aesthetic refinement, aligned with the image of a modern monarchy. The Queen, known for her love of horses and horse racing, choosing Hermès for its equestrian gear, **reinforces the brand's image as a premier choice for connoisseurs around the world.**

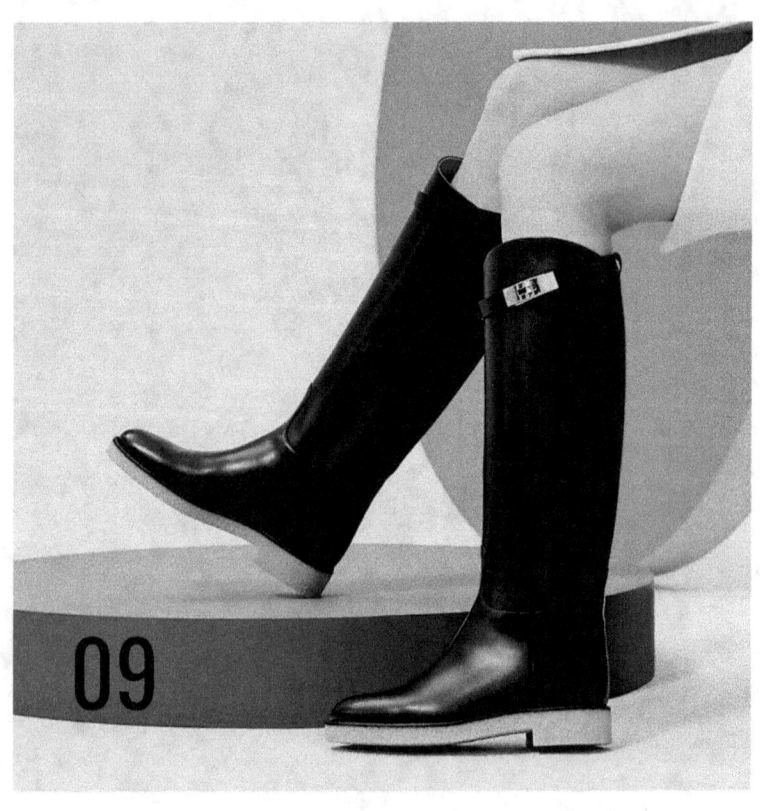

Originally a harness and saddle manufacturer,
Hermès is today a luxury group specializing in leather goods, ready-to-wear, perfumery, watchmaking and tableware. The Hermès house is still controlled by the Hermès dynasty, descendants of the founder.

HERMÈS

Hermès stores are famous not only for their luxury and exclusivity, but also for their unique architectural design that reflects the brand's values. An emblematic example is the Hermès store located at 24, rue du Faubourg Saint-Honoré in Paris. This store, which is also the company's headquarters, opened its doors in 1880 and represents the historic heart of Hermès. What is particularly remarkable about this store is its atmosphere which combines tradition and modernity, illustrating the balance between heritage and innovation that characterizes Hermès.

In addition to selling luxury products, the Faubourg Saint-Honoré store is known for its "Le Plongeoir", a conceptual space imagined by artist Hilton McConnico in 2010. This artistic installation functions as a presentation theater for products, but also as an exhibition space for works of art, creating an immersive and cultural shopping experience. This shows how Hermès uses its spaces not only to market products but also to engage its visitors in the aesthetic and deep philosophy of the brand, making each visit a rich and memorable experience.

Hermès by Hilton McConnico | Whiny Pencil | Hermes, Pop up bar, Exhibition design

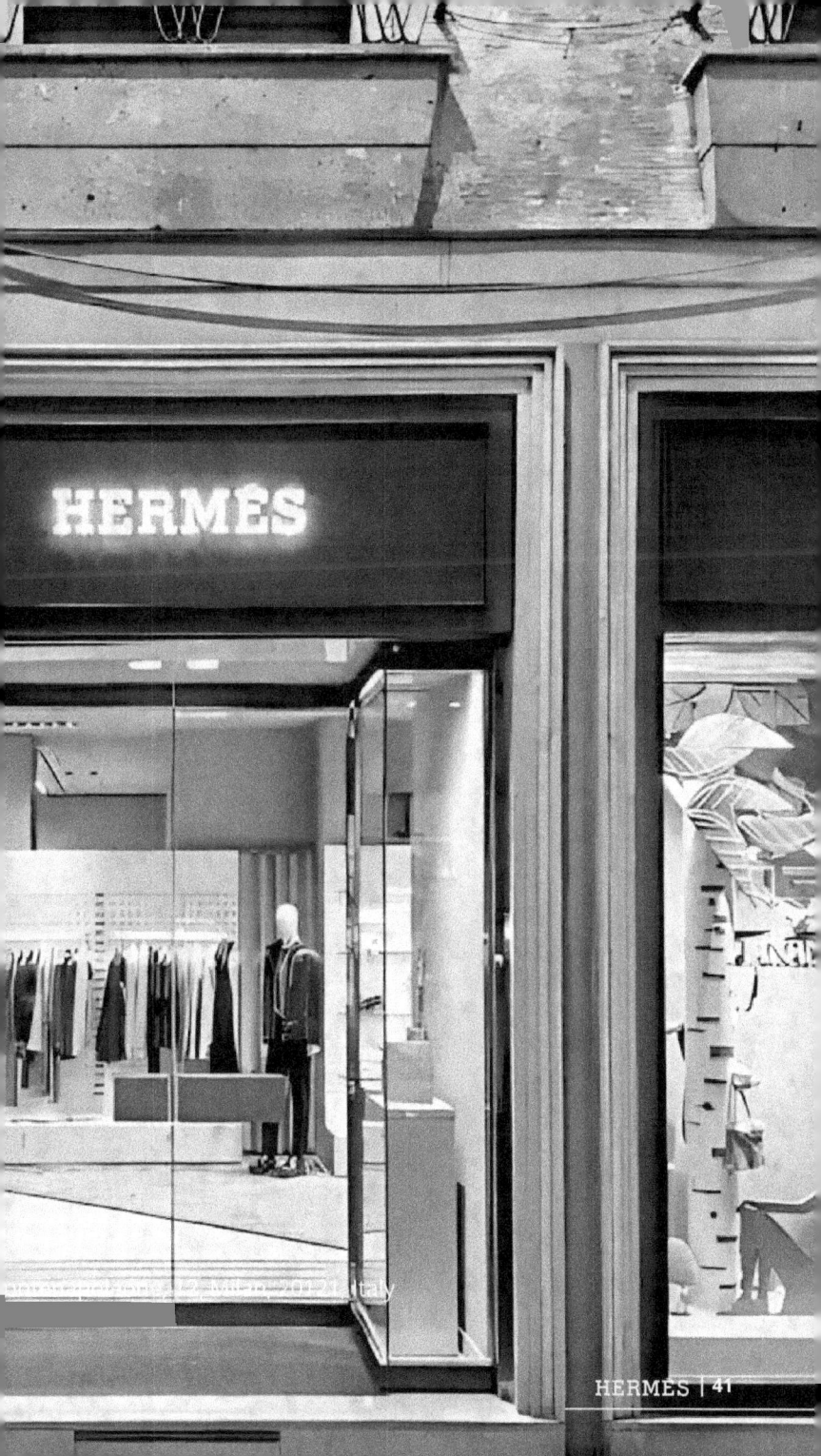

10

Commitment to sustainability and green practices. In 2010, Hermès launched "Petit h", a creative initiative which aims to reuse materials and scraps from other house collections to create unique objects. Led by Pascale Mussard, a member of the sixth generation of the Hermès family, this product line includes items ranging from jewelry to furniture pieces, all made from recycled materials. This approach illustrates Hermès' commitment not only to maintaining a level of luxury and quality, but also to promoting more responsible production and reducing waste.

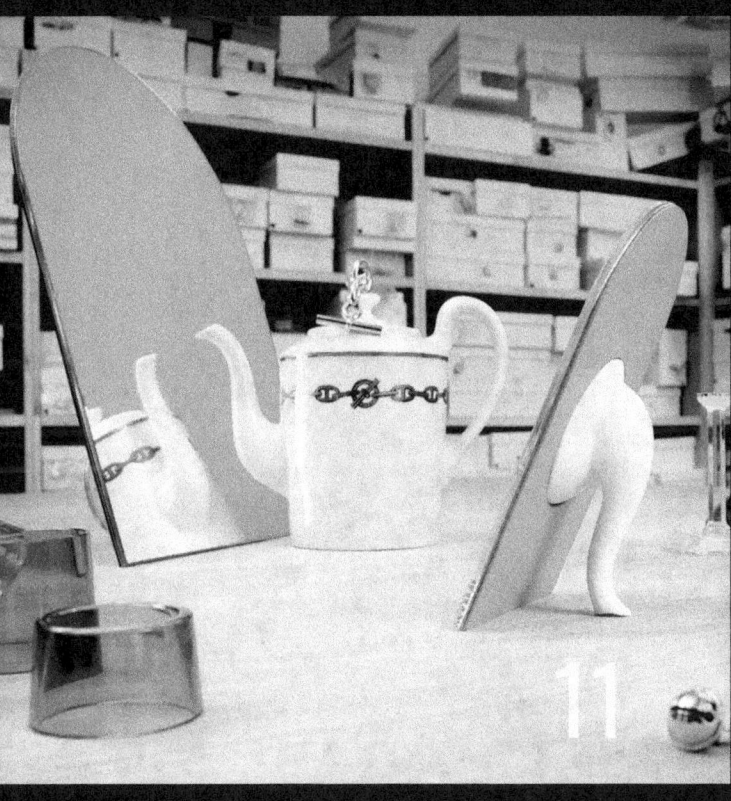

The material cellar
Silk, leather, fabric, porcelain, crystal, pieces of goldwork, etc., are made available to create unexpected associations between these dormant materials, in a spirit of reinvention and responsibility.

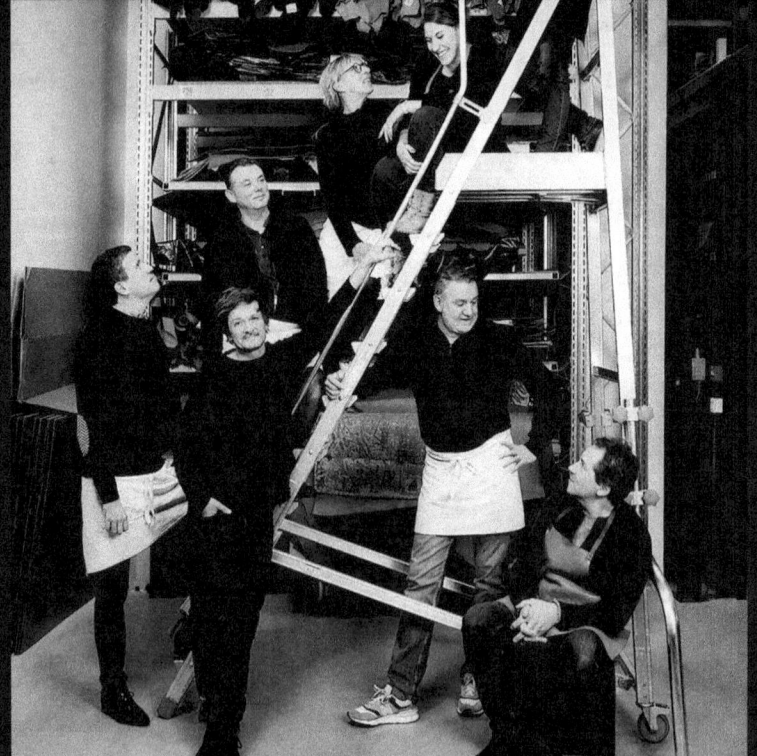

12

Expert artisans from the different Hermès professions who work hand in hand with guest artists and designers around Godefroy de Virieu, creative director of petit h.
A creative process that gives rise to functional and unique objects.

13

Reinventing everyday objects and combining new materials and know-how. Obvious encounters like that of earth with leather or crystal.

www.hermes.com

14

The secrets of an object

Its sweet melody takes us into the world of dreams and childhood. This music box, designed by the petit h workshop, is created from materials available in material cellars. The key – in feathers, Brandenburg-style horn or porcelain, meets leather goods with the leather sheathing of the beech wood sphere. To dive into the arms of Morpheus, simply wind the key clockwise to ring out the notes of an essential classic melody.

FUZZY NECKLACE

15

The secrets of an object

This colorful necklace takes shape thanks to silk spaghetti, chosen based on the squares available in the material cellars of the petit h workshop. Placed randomly, colors and patterns unfold and add movement to the silhouette. On the clasp, two leather bells reinforce and finalize the silk straps to wrap around a Clou de Selle button. A cheerful accessory to wear for any occasion.

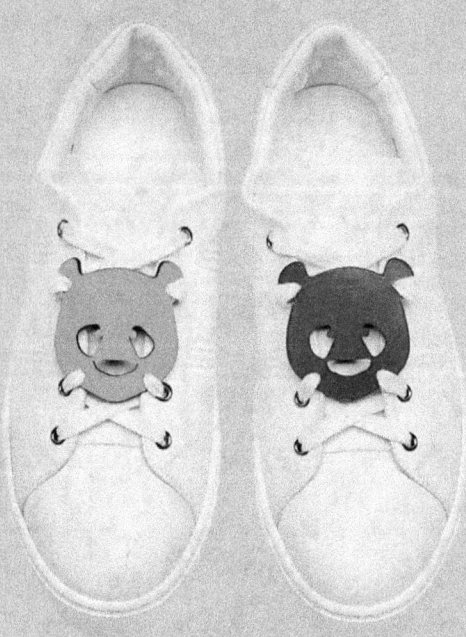

PANDA SHOE ACCESSORY

16

Each petit h product is unique.
The materials, patterns and colors will therefore be a surprise!

Accessory for shoe in calfskin, in the shape of a panda. This accessory is removable and reversible, and easily attaches to all types of lace-up shoes.

Made in France

ICONIC　　　　　　　　　　　　　　　　　　　　　　　　　　　DESIGN

PREVIEW

[SCENT]

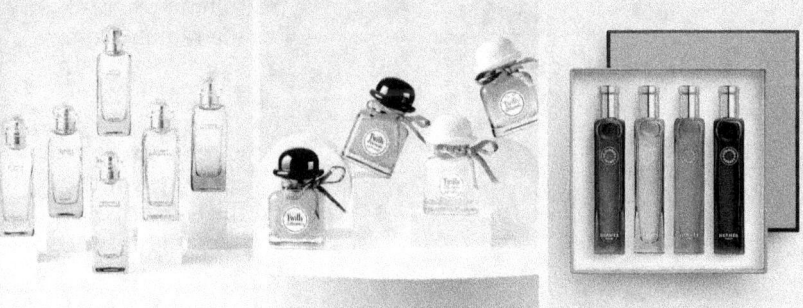

Hermès perfumes are designed to tell stories, inspired by travel, dreams and explorations of nature. This narrative approach is found in collections such as "Les Jardins", which evoke the scents of different gardens around the world, offering a unique sensory escape to those who wear them. By choosing an Hermès perfume, you are not just buying a fragrance, but part of an artistic and creative heritage that has made Hermès a legend in luxury.

TRENDS
PROJECTS
COLLECTIONS
FACES DESIGNERS
AWARDS

PARIS 🌐

WWW.HERMES.COM

HERMÈS
PARIS

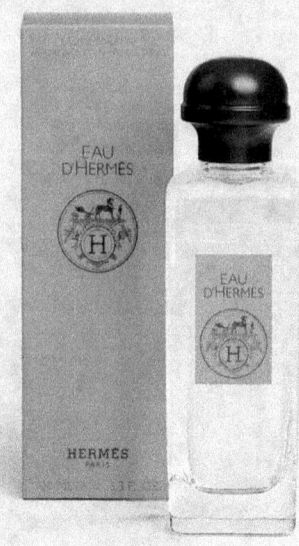

A citrus and spicy fragrance, Eau d'Hermès is an eau de toilette where the radiance of lemon petitgrain and the dazzling energy of cardamom combine with the warmth of cinnamon.

17

Hermès perfumes occupy a special place in the world of haute perfumery, reflecting the elegance, innovation and finesse that characterize the brand. Since the launch of its first perfume, **"Eau d'Hermès"**, in 1951, the house has continued to develop fragrances that capture the essence of its artisanal heritage while incorporating modern and inventive touches.

A warm, woody fragrance, Terre d'Hermès Parfum combines enveloping cedar and sparkling grapefruit with a radiant shiso note.

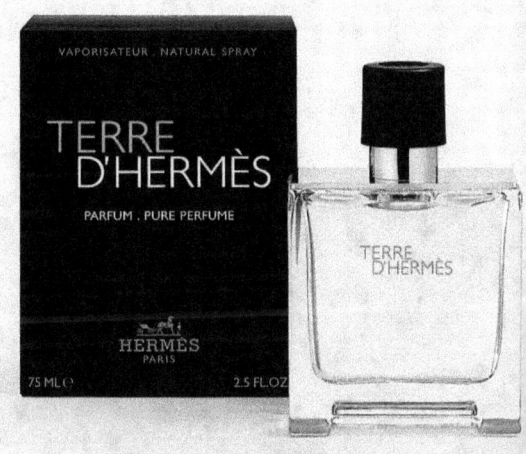

18

Each Hermès perfume is designed as a work of olfactory art, created in close collaboration with renowned perfumers. Jean-Claude Ellena, for example, was Hermès' in-house perfumer for several years, and he is famous for his minimalist approach and meticulous use of the highest quality ingredients. Under his leadership, Hermès launched iconic fragrances like **"Terre d'Hermès"** and **"Jardin sur le Nil,"** which have become modern classics beloved for their originality and sophistication.

history

THE
Thierry Hermès
EDITING

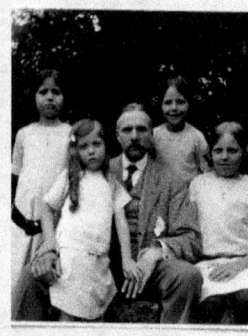
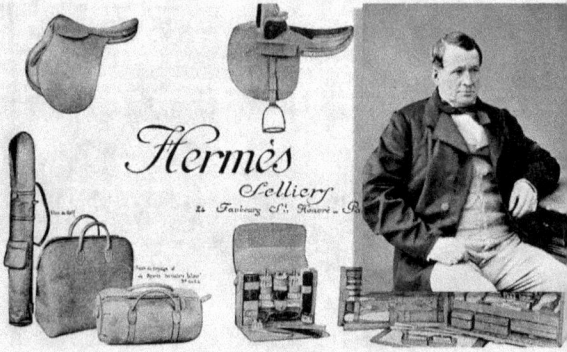

couturier

Thierry Hermès, born in 1801 in Krefeld, Germany, is the founder of the house of Hermès, one of the most iconic and respected luxury brands in the world. From a young age he was introduced to leather craftsmanship

A know-how that will accompany him throughout his life. Motivated by this passion, he moved to Paris where he opened his first shop in 1837, specializing in the manufacture of high quality harnesses and saddles for European nobility. This company, initially focused on the needs of equestrian crews, laid the foundations for what would later become a luxury empire, diversified into leather goods, fashion, perfumes, and many other areas, while remaining faithful to the initial commitment to quality and artisanal excellence of its founder.

HERMÈS SHOP OF HISTORY

REVOLUTION IN LUXURY FASHION

Hermès handbags and accessories constitute a fundamental pillar of the house's offering, symbolizing the luxury, tradition and innovation for which the brand is globally recognized.

Through its varied leather goods collections, Hermès continues to demonstrate its exceptional mastery of leather craftsmanship, merging artisanal heritage with contemporary touches to offer a rich range that meets the tastes and demands of a discerning international clientele.

These creations, combining elegant functionality and refined aesthetics, are the result of know-how passed down through generations, making each Hermès piece a lasting symbol of sophistication and style.

The glamor of Grace Kelly

Grace and her Kelly. It was at the end of the 1950s that the famous belt bag, produced by Hermès since 1935, entered the fashion pantheon.

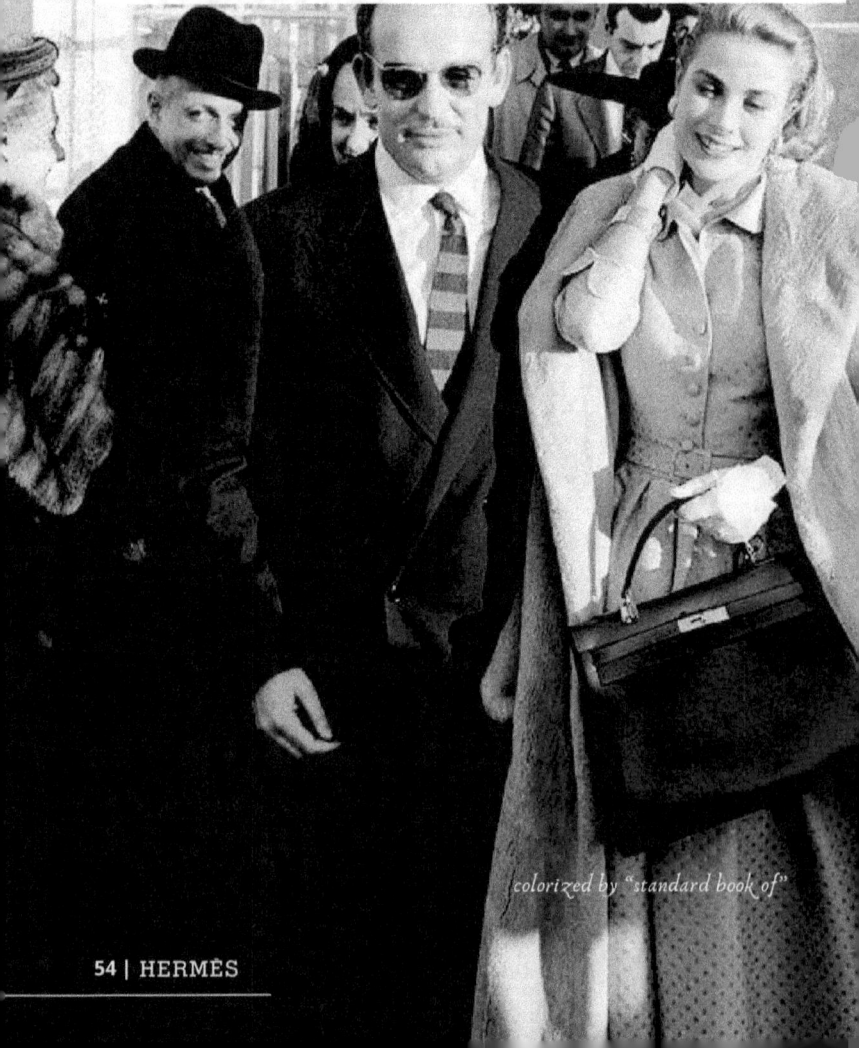

colorized by "standard book of"

The "Kelly" bag

> **" 1956, Grace Kelly is preparing to fly to Monaco to live her new life as a princess. The signature Hermès "Kelly" bag on her arm, a must-have for the icon's style. The proof in pictures. "**

The vintage image of the weekend: Grace Kelly in 1956

HERMÈS

The "Kelly" bag

Grace Kelly's life is a true fairy tale, illuminated by a brilliant career. In the 1950s, she charmed New York and quickly became a rising star thanks to films like "The Crime Was Almost Perfect", "Rear Window" and "The Hand in the Collar", under the direction of the famous Alfred Hitchcock. However, in 1955, her life took a decisive turn when she met Prince Rainier of Monaco during the Cannes Film Festival. Seduced, she chose to abandon her acting career at the height of her fame to marry the monarch.

A key moment in 1956, when she left New York for Monaco, captured in a photograph which highlights her transformation into Princess Grace of Monaco. Known for her impeccable style, **Grace Kelly** is also famous for a particular accessory: the Haut à Belts bag from Hermès, which would later be renamed **"Kelly"** in her honor. She had adopted this bag in 1954 on the set of **"La Main au collet"**, after having discovered it with her seamstress Edith Head. This bag, which she used to hide her pregnancy from the paparazzi, has become an emblem of her elegance. Decades later, the "Kelly" bag remains closely associated with its legendary image, reinforcing the myth of Grace Kelly.

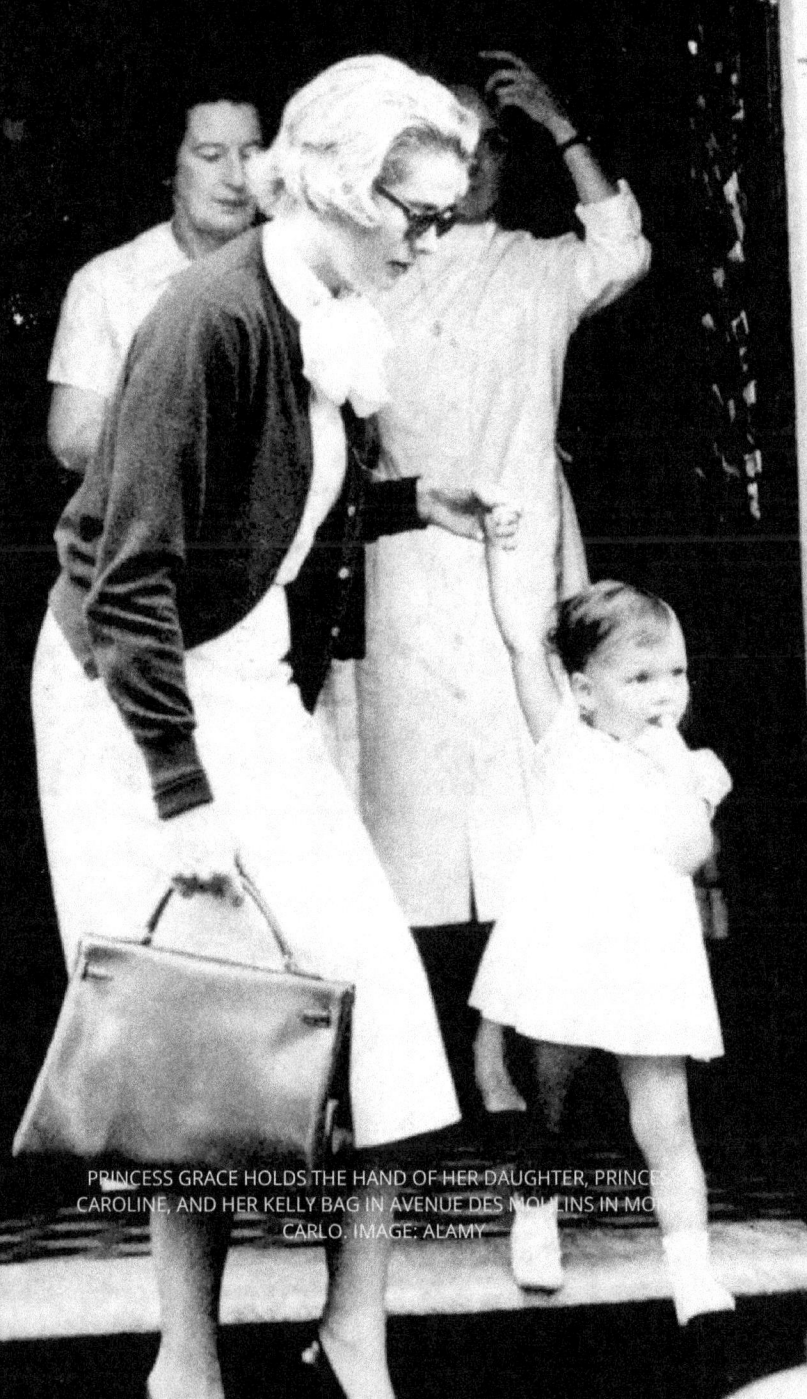

PRINCESS GRACE HOLDS THE HAND OF HER DAUGHTER, PRINCESS CAROLINE, AND HER KELLY BAG IN AVENUE DES MOULINS IN MONTE CARLO. IMAGE: ALAMY

HERMÈS

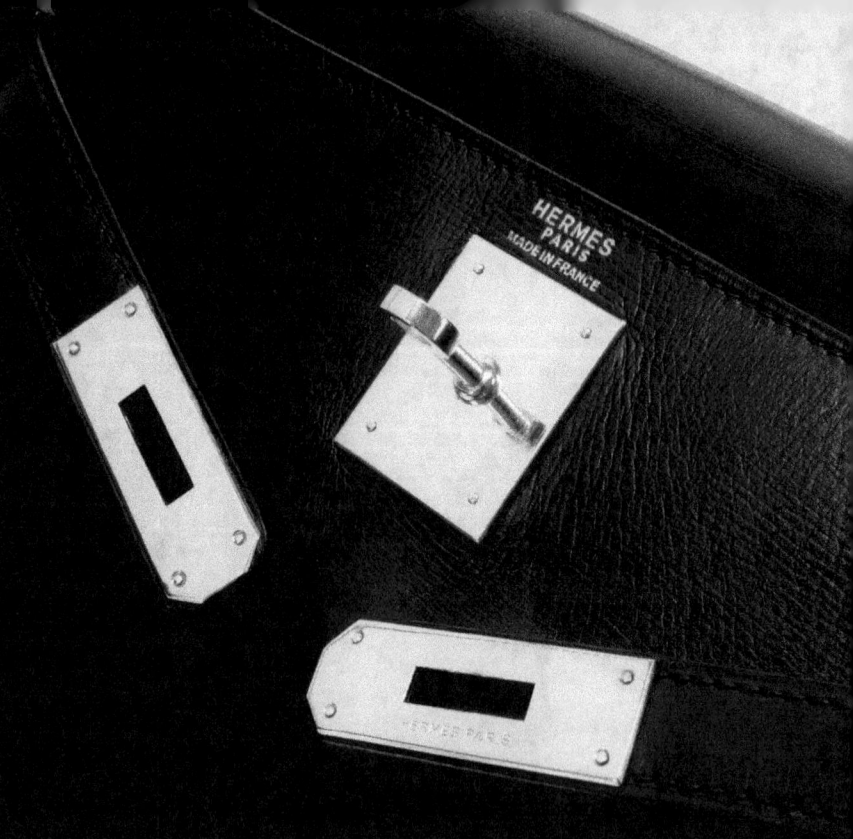

19

Practically perfect

As always at Hermès, the manufacturing of the KELLY is astonishingly perfect. It takes an Hermès artisan between 18 and 20 hours of work to make each bag from start to finish (no assembly lines employed here), with 680 stitches to assemble 36 separate pieces of leather. For an extra touch, the artisan will sometimes go as far as ironing the bag to ensure a smooth surface, before it is carefully inspected for any defects.

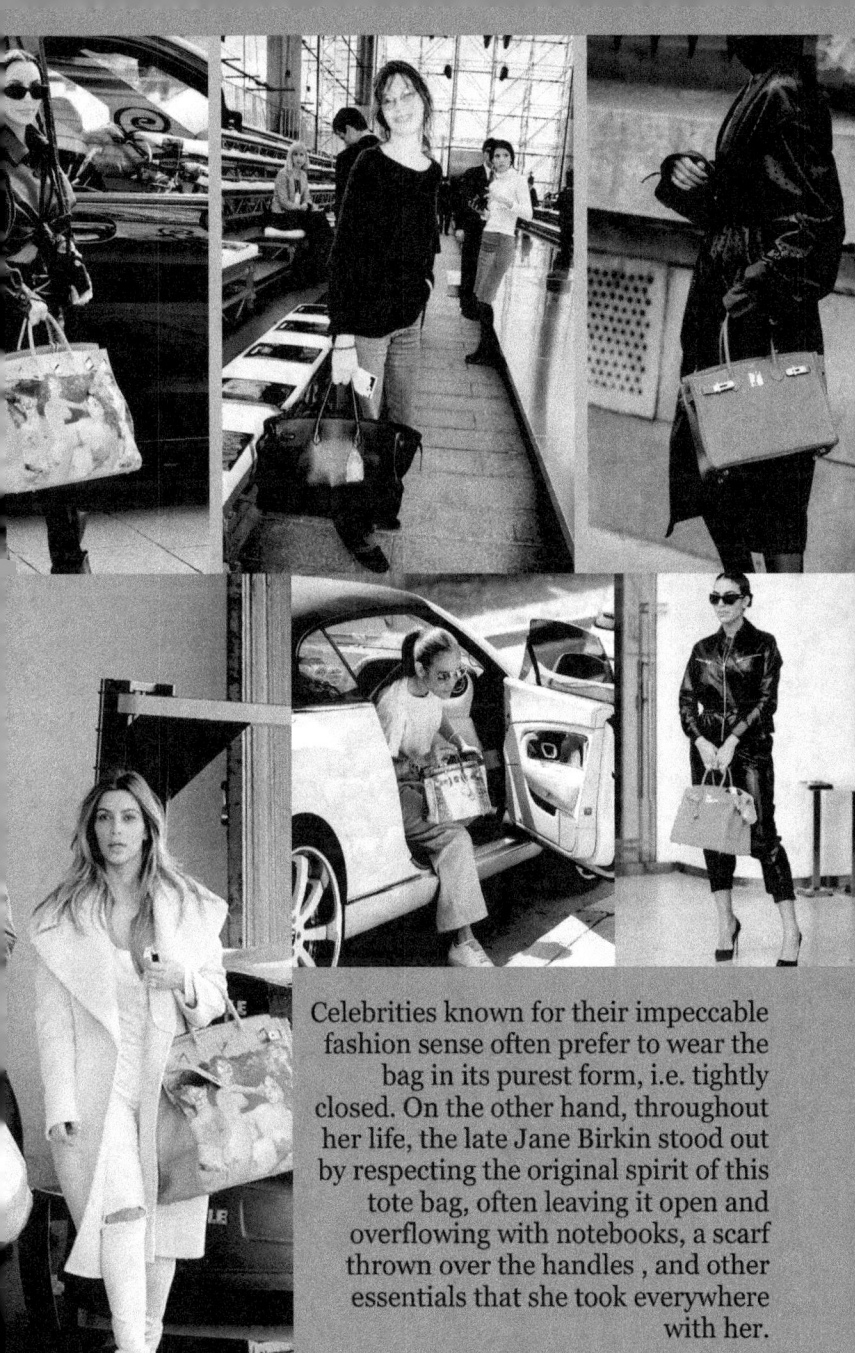

Celebrities known for their impeccable fashion sense often prefer to wear the bag in its purest form, i.e. tightly closed. On the other hand, throughout her life, the late Jane Birkin stood out by respecting the original spirit of this tote bag, often leaving it open and overflowing with notebooks, a scarf thrown over the handles, and other essentials that she took everywhere with her.

BIRKIN
BAG|BLUE

1984

MODE

HERMES

HERMES

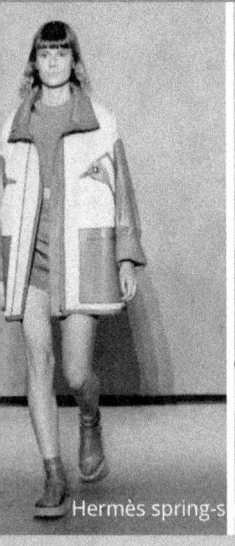
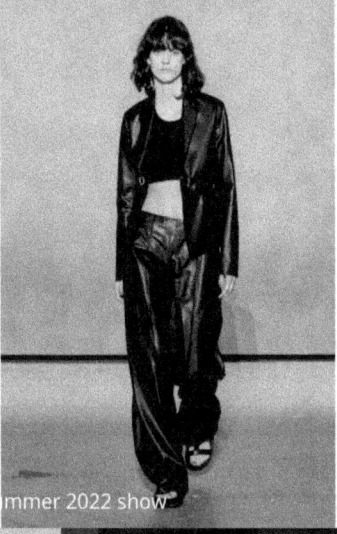
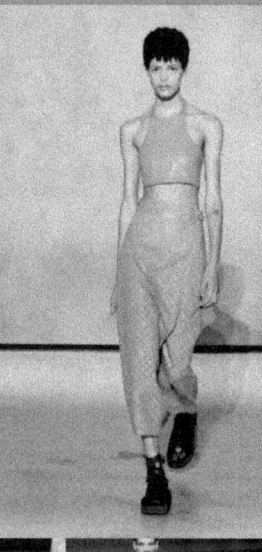

Hermès spring-summer 2022 show

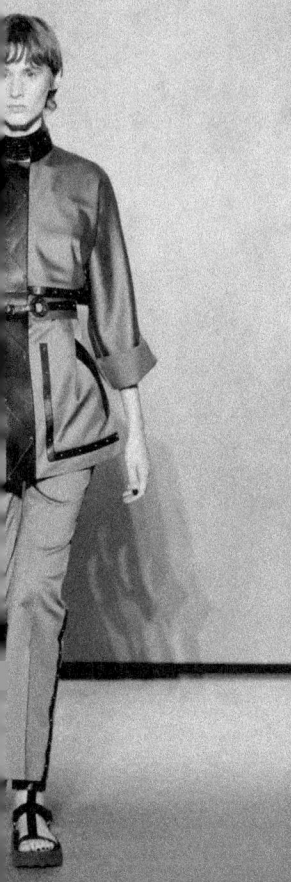
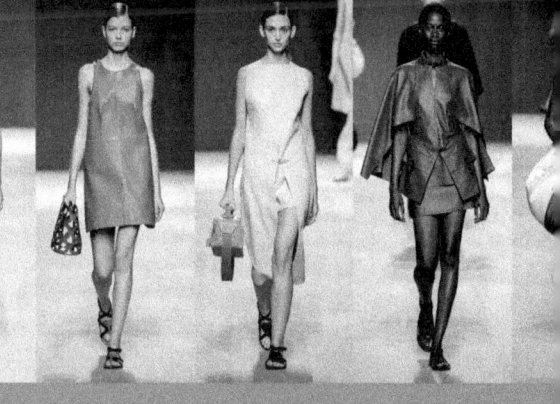

For its spring-summer 2022 collection, Hermès presented a fashion show that embodies the elegance and sophistication inherent to the brand. Organized in the intimacy of the Mobilier National in Paris, this event highlighted the house's mastery in the art of leather goods and ready-to-wear. The color palette was dominated by neutral tones, punctuated with pops of bright colors, providing a subtle but captivating contrast.

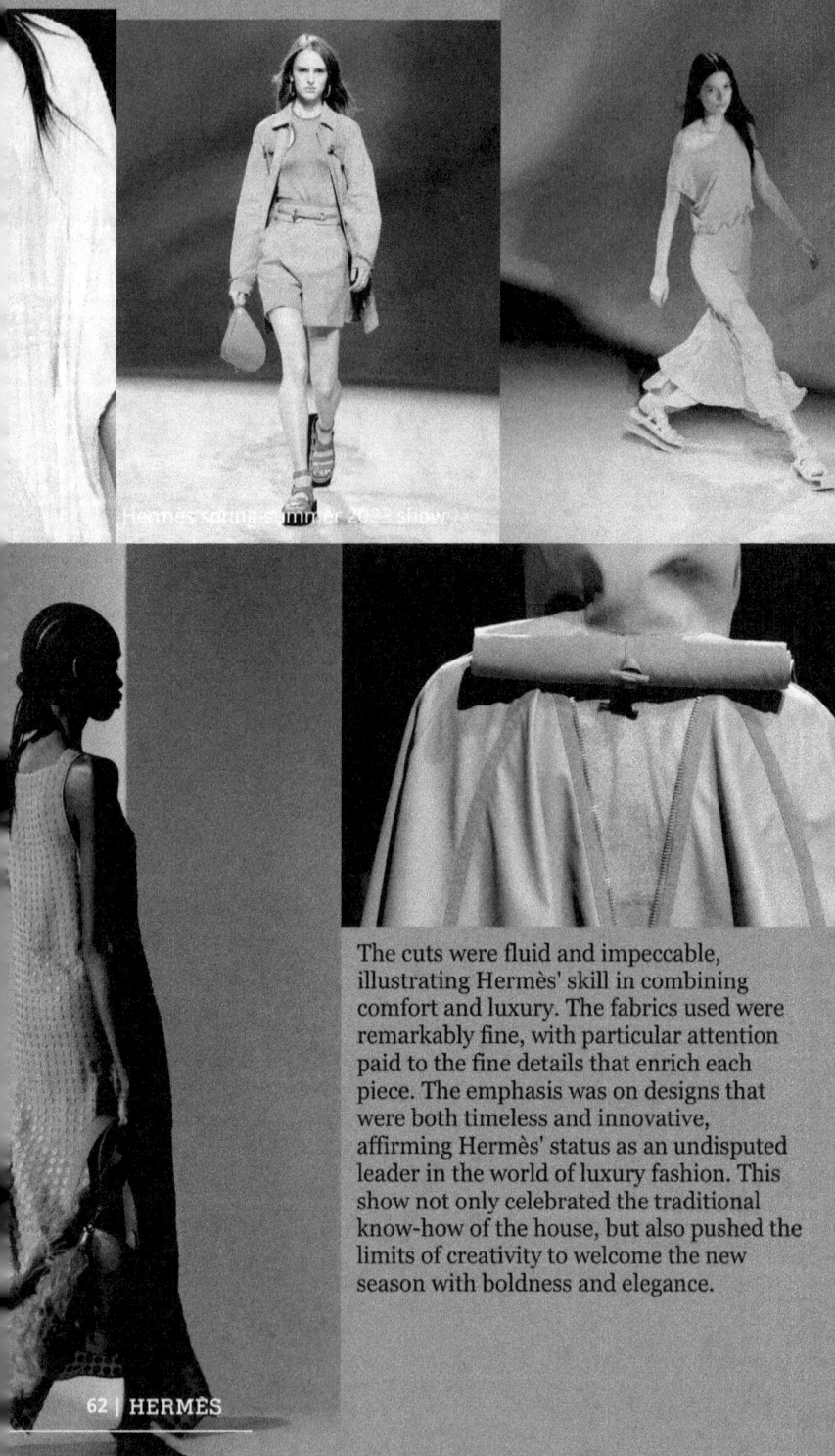

Hermès spring-summer 2022 show

The cuts were fluid and impeccable, illustrating Hermès' skill in combining comfort and luxury. The fabrics used were remarkably fine, with particular attention paid to the fine details that enrich each piece. The emphasis was on designs that were both timeless and innovative, affirming Hermès' status as an undisputed leader in the world of luxury fashion. This show not only celebrated the traditional know-how of the house, but also pushed the limits of creativity to welcome the new season with boldness and elegance.

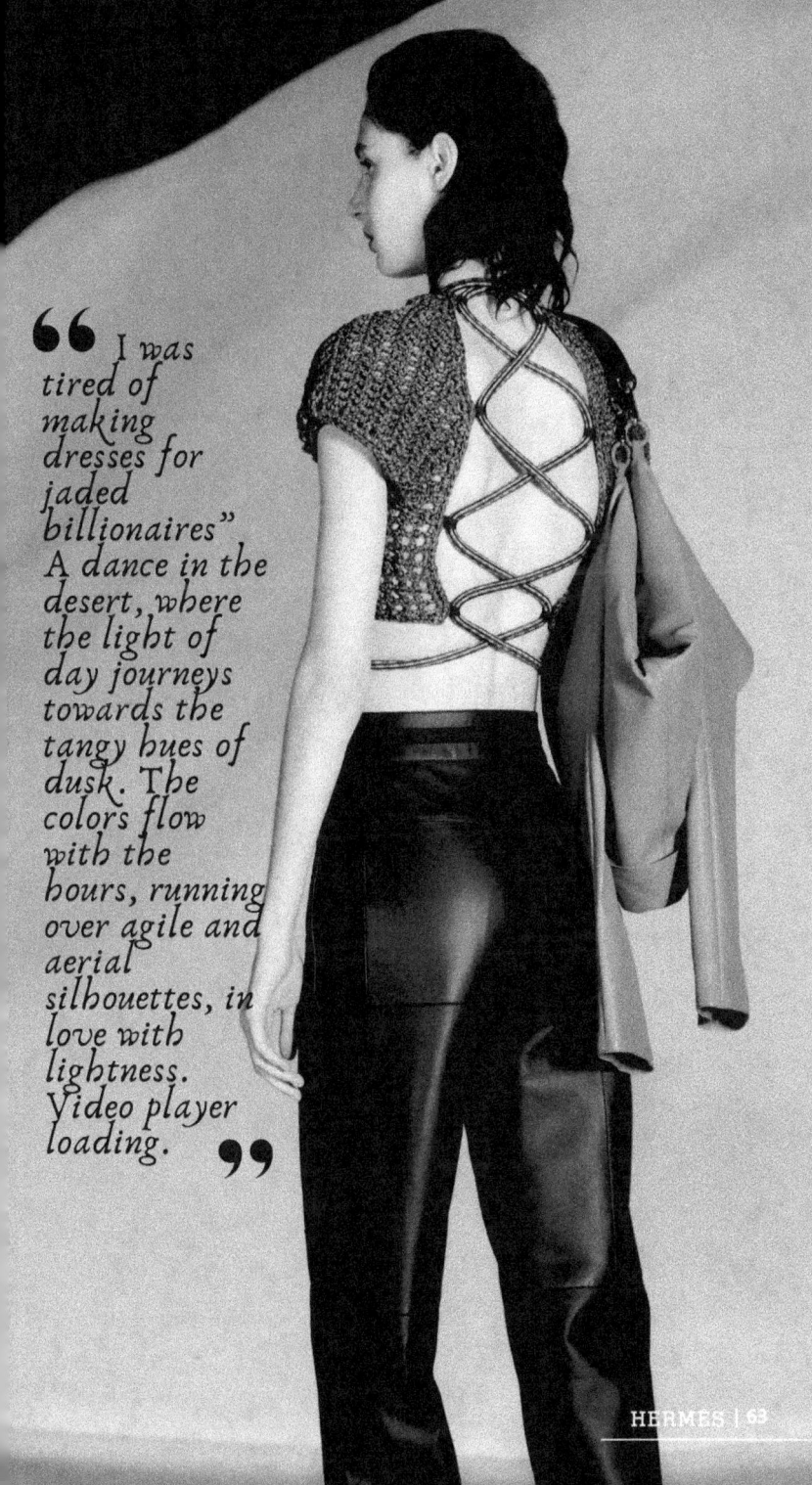

> " I was tired of making dresses for jaded billionaires" A dance in the desert, where the light of day journeys towards the tangy hues of dusk. The colors flow with the hours, running over agile and aerial silhouettes, in love with lightness. Video player loading. "

> "At sunset, everything is effervescent and fluid. The flags take on asymmetrical dresses and float on the dune, bright reds and pinks mingle on light and modular pieces."

UPDATE YOUR LOOK

JEAN JACKET

DENIM (100% COTTON)

SPRING-SUMMER 2024 COLLECTION

The timeless denim jacket is adorned with a leather pocket, a nod to Hermès' love of this know-how.
A piece that will endure through the seasons, acquire a patina and become more refined over time.

hermes.com

UPDATE YOUR LOOK

JACKET SHIRT

COMPACT POPLIN (100% COTTON)

SPRING-SUMMER 2024 COLLECTION

Madison collar boxy body jacket shirt

hermes.com

HERMES

SELLIER, 24, FAUBOURG SAINT-HONORÉ, PARIS — BIARRITZ, CANNES, CHANTILLY, PAU, SAINT-CYR, SAUMUR

...ts d'hiver... Magie blanche... La joie de glisser en silence et de se griser d'air vif et sec... s allez partir, Madame, pour la montagne neigeuse. N'oubliez pas de vous munir de es ces choses délicieusement confortables qui vous sont presque indispensables : la joie vivre se doublera de la joie de plaire. Les ensembles d'HERMÈS, créés pour vous, ame, qui aimez les lainages moelleux aux dessins originaux : Pull-over, bas, chaussettes, s, sacs, écharpes, seront les aimables témoins de vos performances. Ajoutez un de ces fois précieux dont HERMÈS a le secret et, pour votre voyage, un sac ou une mallette ont la marque du grand sellier et vous serez prête à affronter les neiges éternelles.

COLOR, RED H

UPDATE YOUR LOOK

SOFT JACKET
TILTED

SLUB MOHAIR WOOL (58%
VIRGIN WOOL, 27% SILK,
10% MOHAIR, 5% LINEN)

SPRING SUMMER 20_ COLLECTION

Madison collar boxy
body jacket shirt

"STIRRUPS"

UPDATE YOUR LOOK

SPRING-SUMMER 2024 COLLECTION

SLUB MOHAIR WOOL (58% VIRGIN WOOL, 27% SILK, 10% MOHAIR, 5% LINEN)

Madison collar boxy body jacket shirt

hermes.com

Galloping know-how, according to Hermès

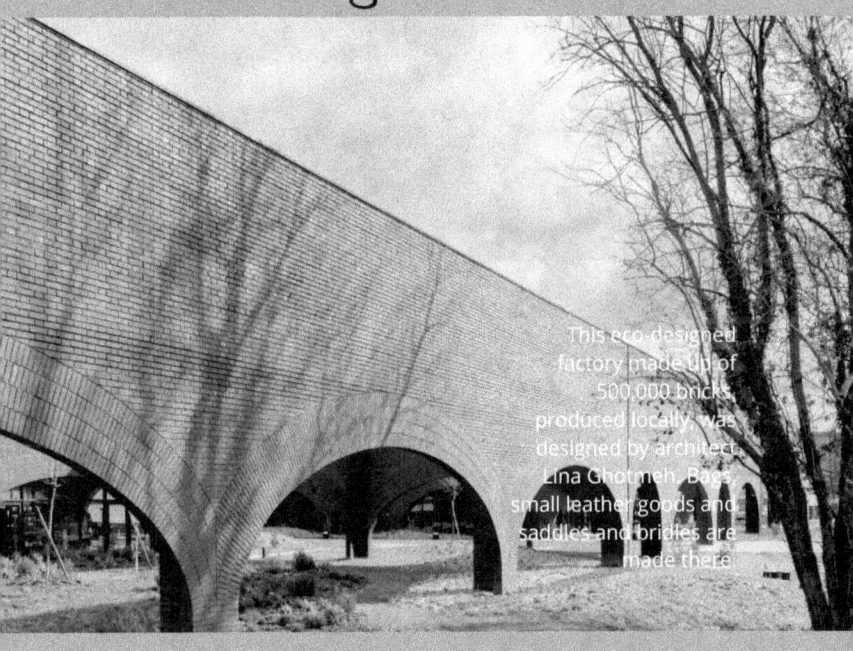

This eco-designed factory made up of 500,000 bricks, produced locally, was designed by architect Lina Ghotmeh. Bags, small leather goods and saddles and bridles are made there.

In the leather goods workshop bathed in light, time seems to stand still. On the workbenches, craftsmen are busy bringing Kelly bags to life, demonstrating their expertise. Beyond its status as a coveted object, the Hermès Kelly bag is one of the most complex models to manufacture, requiring more than fifteen hours of meticulous work. The majority of seams are done by hand. The leatherworker, after coating his thread with wax by rubbing it against a cube, creates the saddle stitch with precision, a symbol of durability and emblem of Hermès' exceptional know-how. **Spread out over 6,000 m2**, the artisans in this space create not only bags but also small leather goods, saddles and bridles.

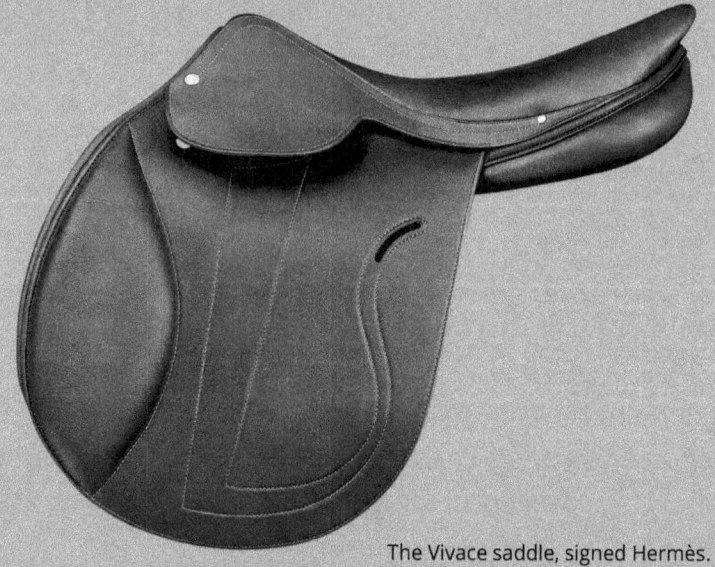

The Vivace saddle, signed Hermès.

Faced with the growing success of its original equestrian activity, the new Hermès factory also includes a specially dedicated workshop. Dressed in sturdy leather aprons, experienced craftsmen make high-quality saddles, tailor-made to the dimensions of the rider and their mount, whether they are amateurs or Olympic-level competitors.

"In the 1980s, Jean-Louis Dumas, noting the cramped space of the workshop in Faubourg Saint-Honoré due to the expansion of the house, considered the creation of a contemporary factory. His idea was to provide a space where artisans could work in peace, bathed in natural light, while respecting our philosophy: one artisan, one bag. If Jean-Louis could see our factory today, he would be proud to see that we followed his directives," confides Pierre-Alexis Dumas, the current artistic director of the house, with a smile.

"

He loved listening to the sounds of the hammer on the leather when you gently tap the seam to flatten it.

he slips, before shutting up and listening. Suddenly, these innocuous noises become almost melodious.

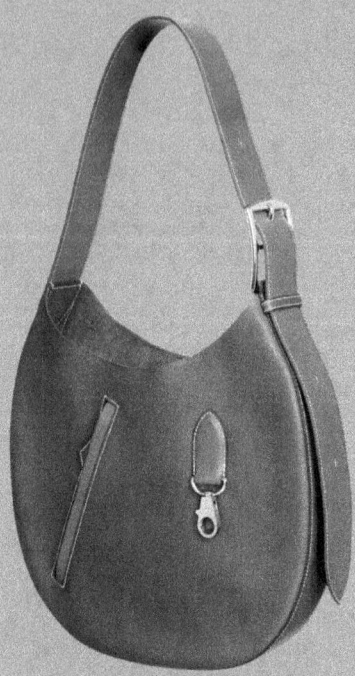

The Arçon bag, in Barenia calfskin, is inspired by the equestrian origins of Hermès. - Flower Studio

Over the last twelve years, Hermès has inaugurated ten new leather goods factories in France, bringing the total number of artisan saddlers and leatherworkers in the group to more than 4,700. Four other manufacturing projects are planned in different regions, testifying to the continued expansion of the brand.

The new Normandy factory, beyond creating jobs, brilliantly illustrates the artisanal and humanist culture of Hermès, which greatly values proximity with its artisans and the transmission of know-how. This site will ultimately welcome 260 artisans trained at the Hermès School of Expertise in Louviers, reinforcing the house's commitment to artisanal excellence and professional education.

EXHIBITIONS AT THE HERMÈS ATELIER

THE FOUNDATION'S EXHIBITIONS

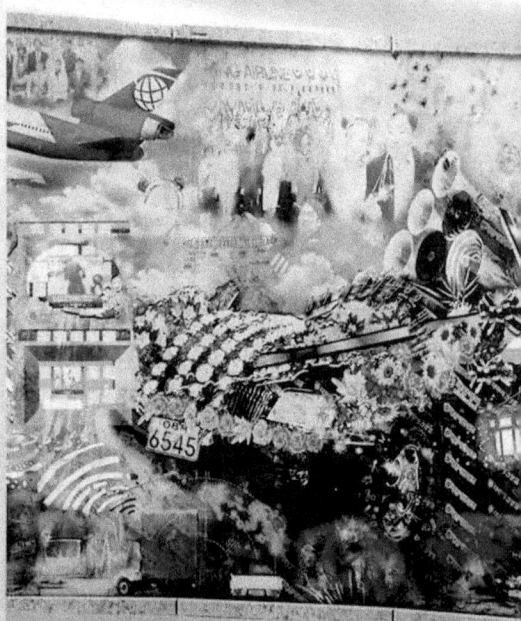

Located within the Maison Hermès in Seoul, Korea, Atelier Hermès is famous for its commitment to contemporary creation, under the direction of artistic director Soyeon Ahn. Focused mainly on Korean art, this exhibition space also opens its doors to international artists, such as the Frenchwoman Laure Prouvost, who inaugurated the program for the year 2022.

View of the exhibition of Sungsil Ryu, "The Burning Love Song", Atelier Hermès, Seoul, 2022 © Sangtae Kim / Fondation d'entreprise Hermès

Laure Prouvost, winner of the famous Turner Prize in 2013, has captured international attention thanks to her immersive narrative installations which immerse the viewer in a poetic universe imbued with humor and reverie. His works, usually populated with strange characters and mysterious messages, often present themselves as theatrical pieces. With this in mind, she designed a space for this exhibition resembling a travel agency called Deep Travel Ink., which also inspires the title of the exhibition.

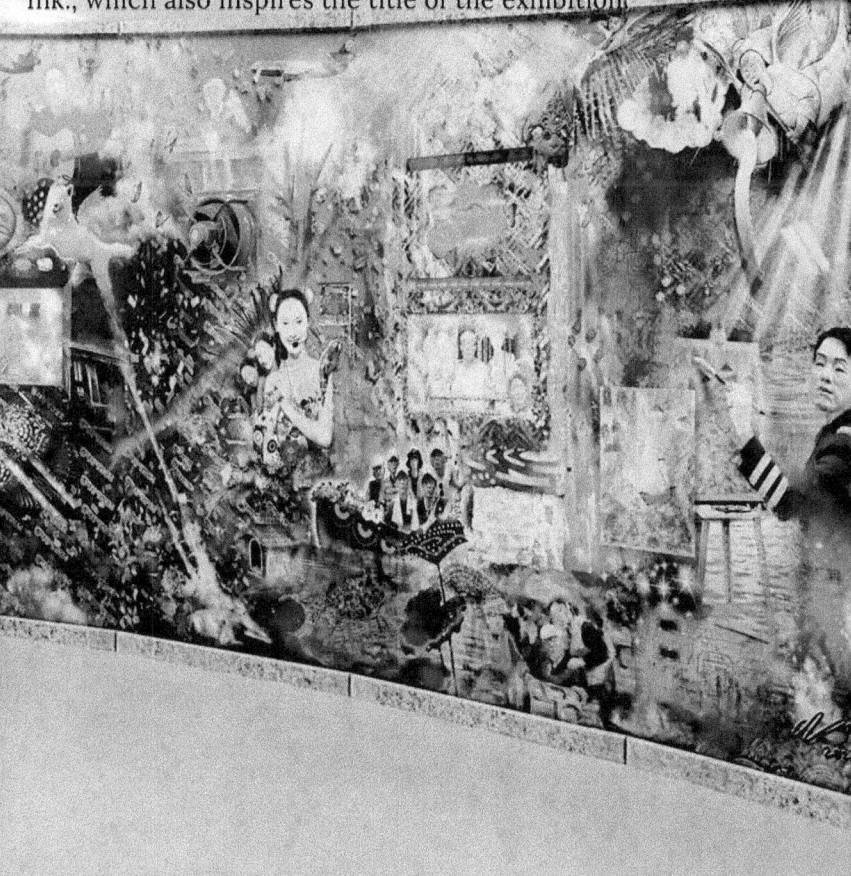

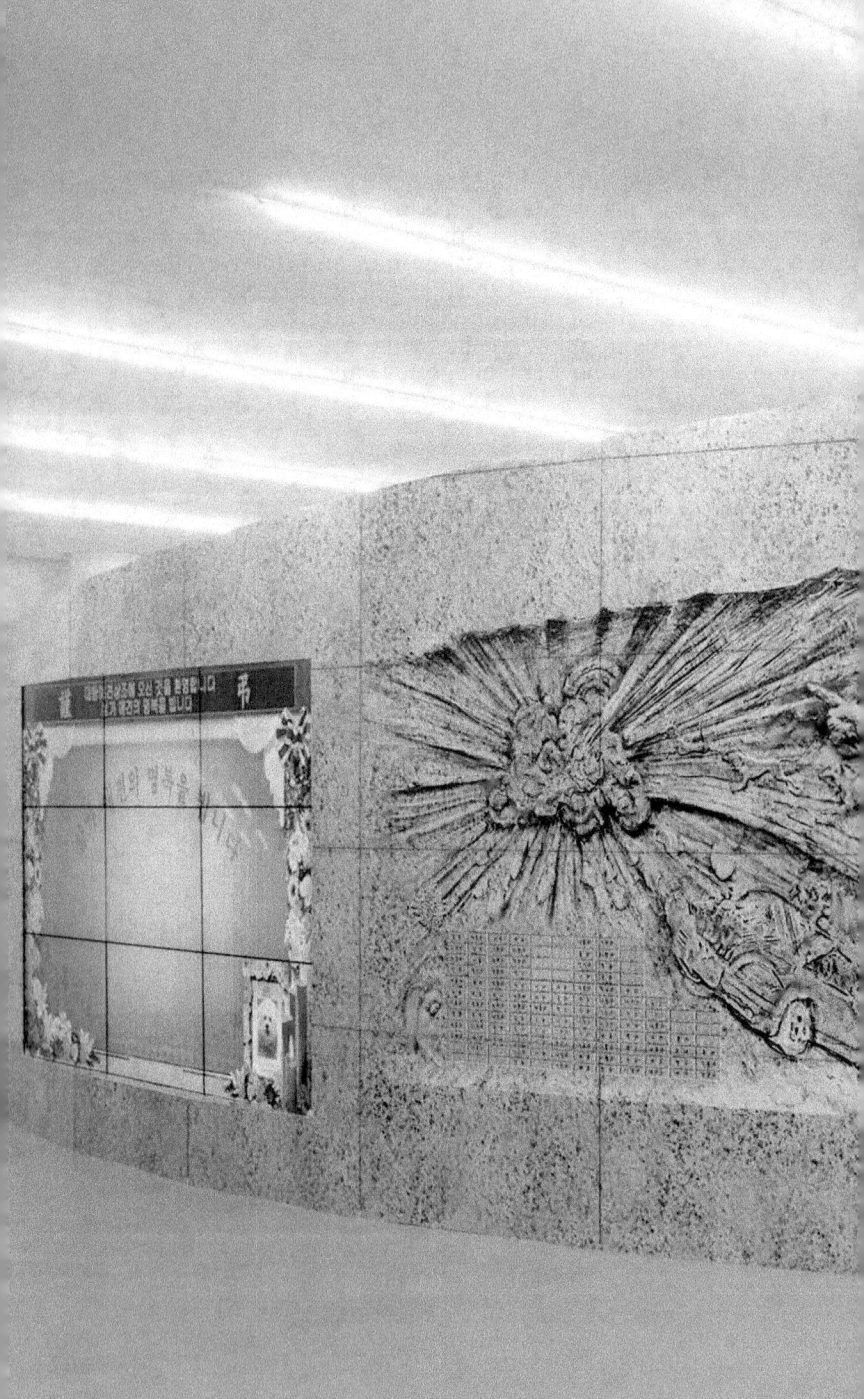

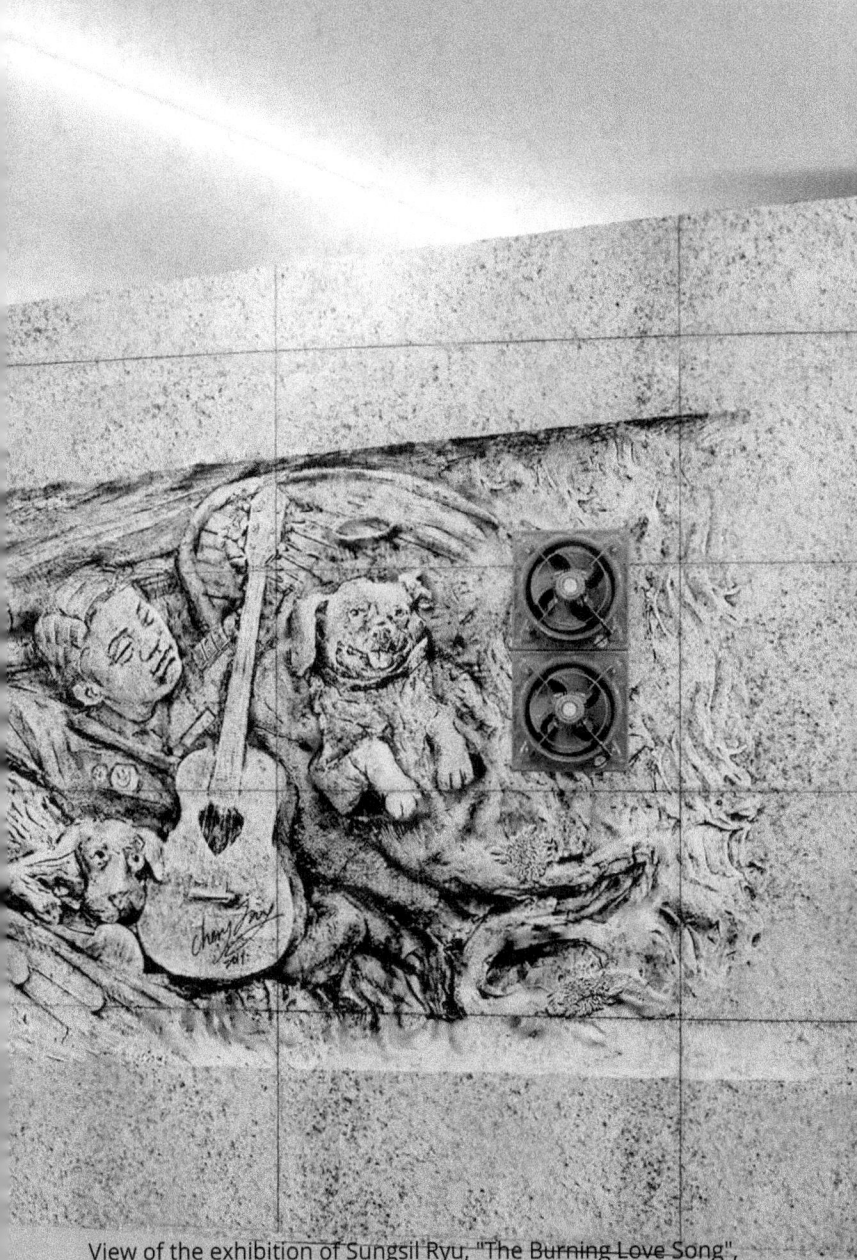

View of the exhibition of Sungsil Ryu, "The Burning Love Song", Atelier Hermès, Seoul, 2022 © Sangtae Kim / Fondation d'entreprise Hermès

The Hermès logo, representing a duke coupled with a groom, is indeed deeply anchored in the history and identity of the brand. Adopted in the 1950s, this symbolic logo was inspired by a work by the French painter Alfred de Dreux, known for his paintings of equestrian scenes. The specific work that inspired the logo is often cited as **"The Duke harnessed to the gala horse guided by a groom"**, which perfectly illustrates the elegance and nobility associated with the equestrian world.

This choice of logo is not insignificant, as it reflects Hermès' origins as a manufacturer of high-quality harnesses and saddles for the European aristocracy in the 19th century. By choosing such a symbol, Hermès pays homage to its heritage while highlighting its expertise in leatherworking, a skill that remains at the heart of the brand's identity.

> *they symbolize the fusion of tradition, luxury and artisanal quality, values that Hermès continues to cultivate through all its collections, whether leather goods, ready-to-wear or accessories.*

Limited edition

"GRAFF HERMÈS SCARF 45 BY KONGO"

Introduced in 1937, Hermès silk scarves have established themselves as one of the most representative symbols of this illustrious luxury house. For more than eight decades, **Hermès has called on around 100 of the greatest contemporary artists** to enrich its collection of more than 2,000 scarf models. Among these remarkable collaborations is that with the famous street art artist, **Cyril Kongo. The 2011 Graff collection**, produced in partnership with Kongo, is distinguished by its 45 cm x 45 cm silk squares, where typography bursts out in an exuberant explosion of colors. These creations demonstrate that Hermès, like a constantly evolving world, remains dynamic and innovative.

Cyril Kongo's work is distinguished by **his rich experience and his unique vision of life.** Active in street art for more than 30 years, he has worked to transform the perception of graffiti, raising it to the rank of a respected and recognized art form. Today, he is seen as a pioneer who broke conventions to offer a contemporary and avant-garde perspective to his art. His style is influenced by cultural diversity, and his commitment to excellence has allowed him to create links between worlds often considered opposed.

Recognized for his excellence, his generosity and his ingenuity, Cyril Kongo emerged from an often marginalized environment to become an essential figure on the international artistic scene. Its strong identity and distinct universe have opened the doors to prestigious collaborations with fashion and luxury giants such as **Hermès, Chanel, and Richard Mille,** as well as houses specializing in artistic crafts such as La Cornue , **Pinel&Pinel, Atelier Victor, and Daum..**

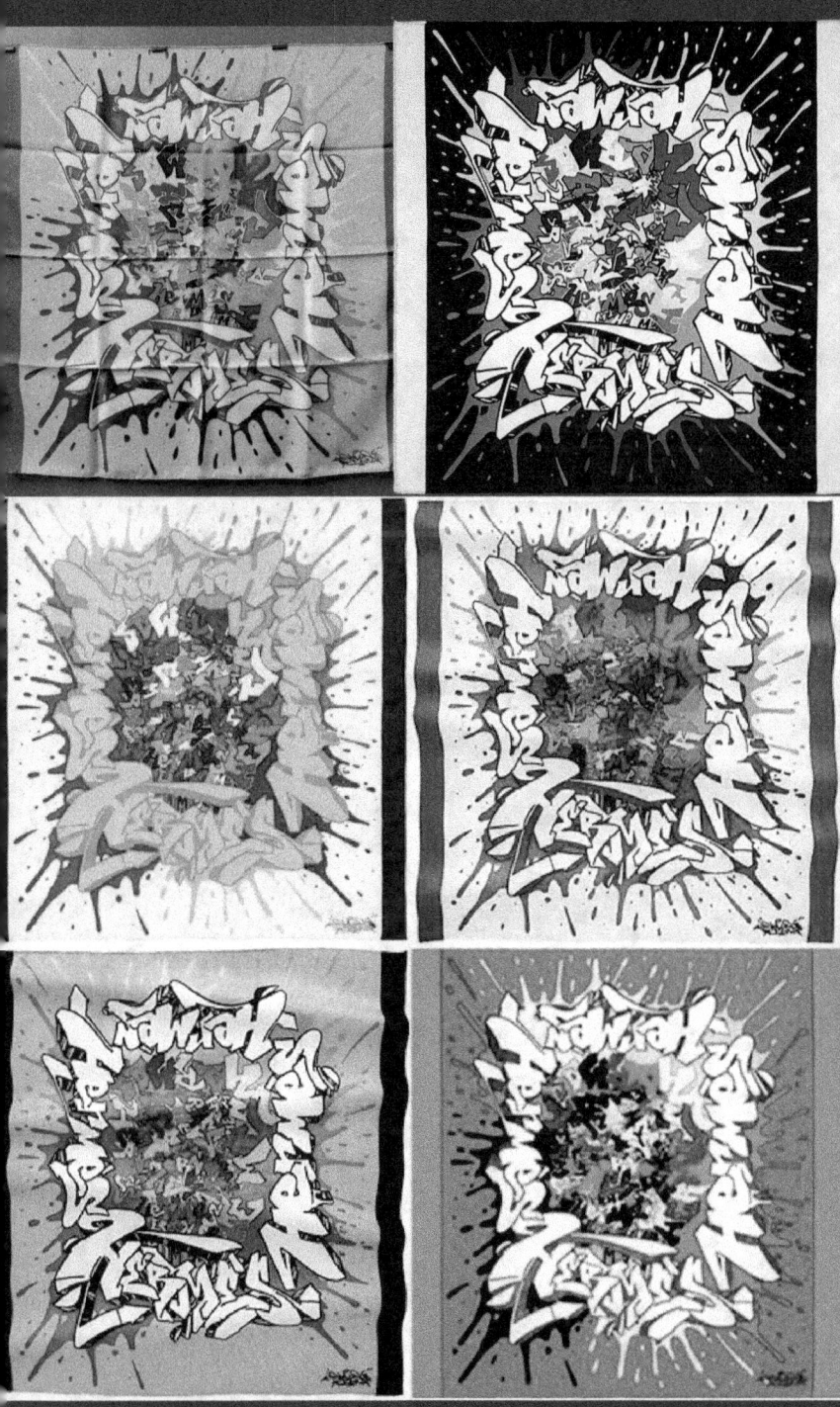

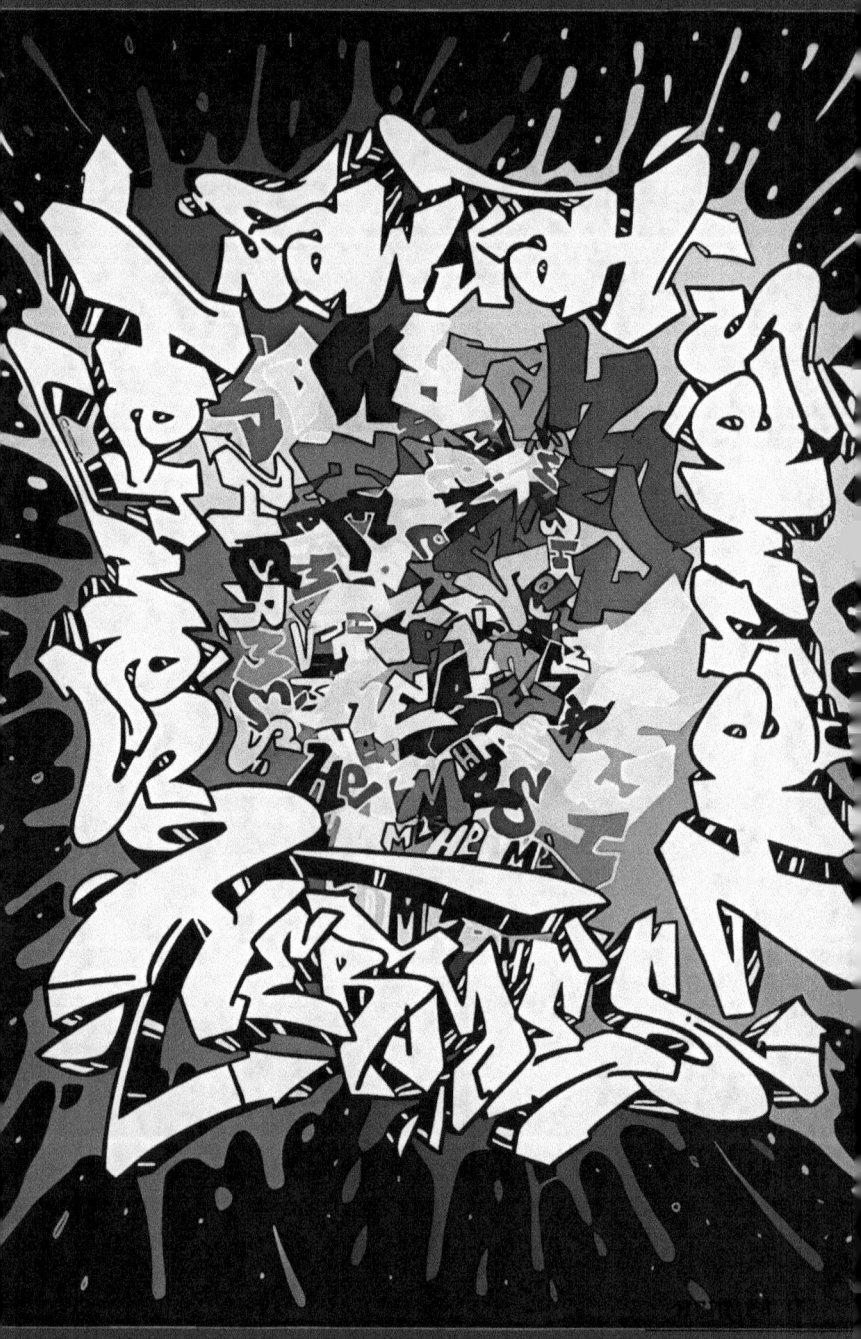

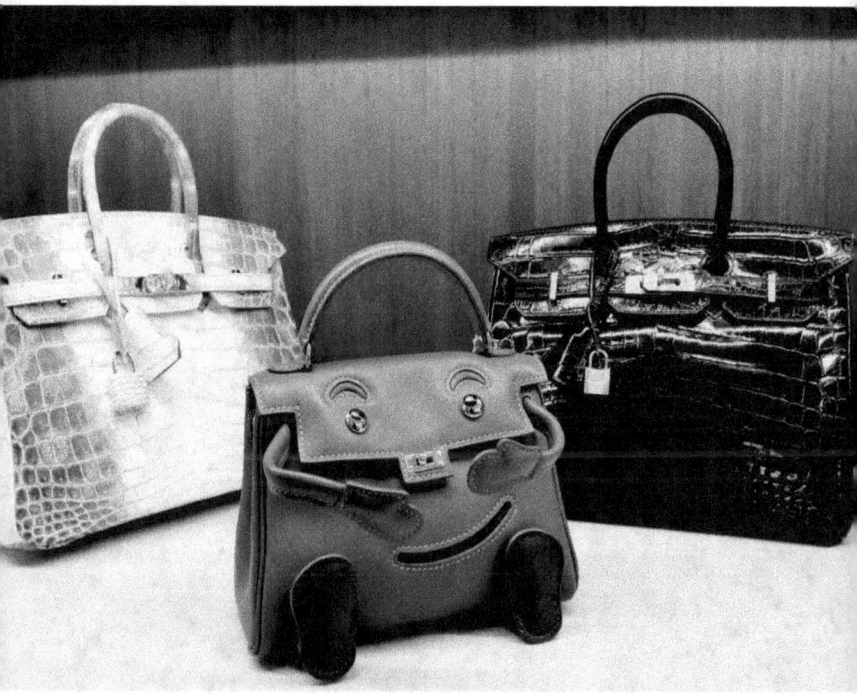

Since 1984, the Birkin has been available in several materials and dozens of colors.

The Hermès Birkin bag has become legendary in particular because of its rarity. It is often said that you have to be on a waiting list to be able to buy it, as a salesman points out to Samantha in an episode of the iconic series **"Sex and the City"**.

In reality, **Hermès reserves this bag for its most loyal and wealthy customers**. Celebrities such as Victoria Beckham, Kim Kardashian, Jennifer Lopez, and Eva Longoria have been seen sporting this ultimate symbol of luxury. In 2023, the average price of a Birkin will be around 7,000 euros.

Hermes - Air Creation - Iris Strubegger - FW 2009

"Hermès merges timeless luxury and exceptional artisanal know-how"

PHOTO: Peter Lindbergh

In the sky of fashion, Hermès spreads its wings, On winds of silk, flight imbued with lightness, Each piece, a journey where the artisan models Dreams woven into scarves of beauty.

The leather curves gently, under expert hands, A Birkin is born, a legend with pure shine, Luxury that dances, elegant and alert, Symbol of a refined and safe world.

Floating squares, in flight in a ballet, Colors that sing on the canvases of Paris, Hermes, master of the air, in his palace, Makes the ephemeral waltz with precision.

O Hermes, you are the guardian of lightness, In every gesture, in every sovereign detail, Your eternal grace, where everything is order and beauty, Luxurious alchemy, where every flight is a feast.

Jane Herendes

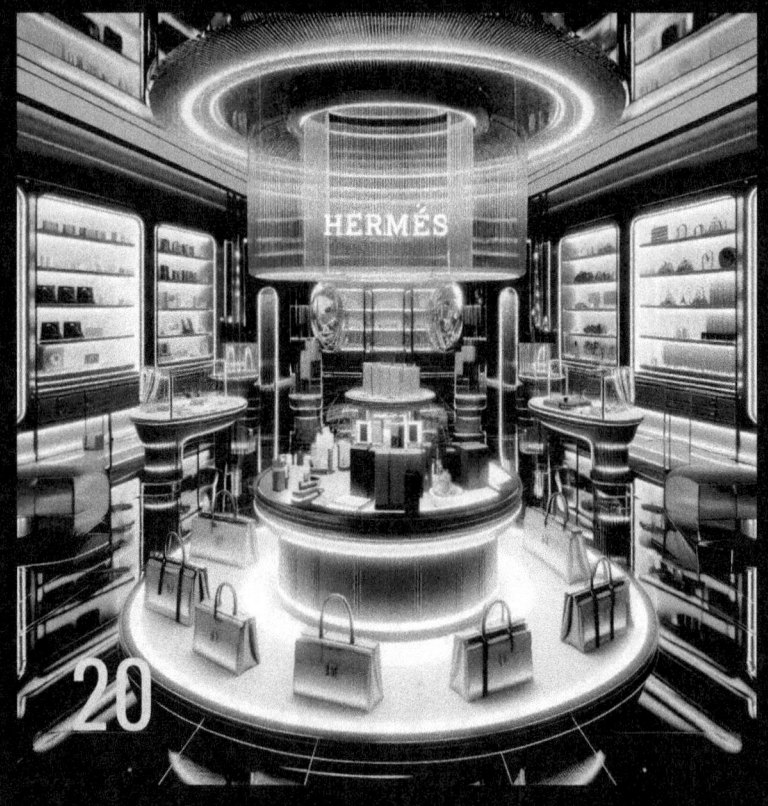

Hermès is preparing to enter the world of Web3, having submitted a trademark application to the United States Patent and Trademark Office (USPTO) on August 26. This application seeks to protect the use of downloadable software designed for viewing, storing and managing virtual goods, including digital collectibles, cryptocurrencies and NFTs, specifically for online environments.

Hermès, the famous French luxury house, is **looking to the future by exploring the emerging world of Web3**. This strategic move is highlighted by its recent trademark application filed with the United States Patent and Trademark Office (USPTO) on August 26. This application aims to secure the rights to use downloadable software specifically designed for the digital world, where the viewing, storage and management of virtual goods, including digital collectibles, cryptocurrencies and NFTs, will be made possible.

In this ever-changing online environment, Hermès seeks to expand its footprint and deliver an immersive luxury experience to its customers. Protecting its brand in the Web3 domain demonstrates its commitment to remaining at the forefront of innovation and meeting the changing needs of its consumers, while preserving the values of exclusivity and authenticity for which it is renowned. .

As the digital world continues to expand and evolve, Hermès is boldly positioning itself to embrace this new technological era while maintaining the artisanal excellence and prestigious heritage that has characterized the brand for decades. This initiative marks an important milestone in the history of Hermès, paving the way for new opportunities and strategic expansion in the digital domain.

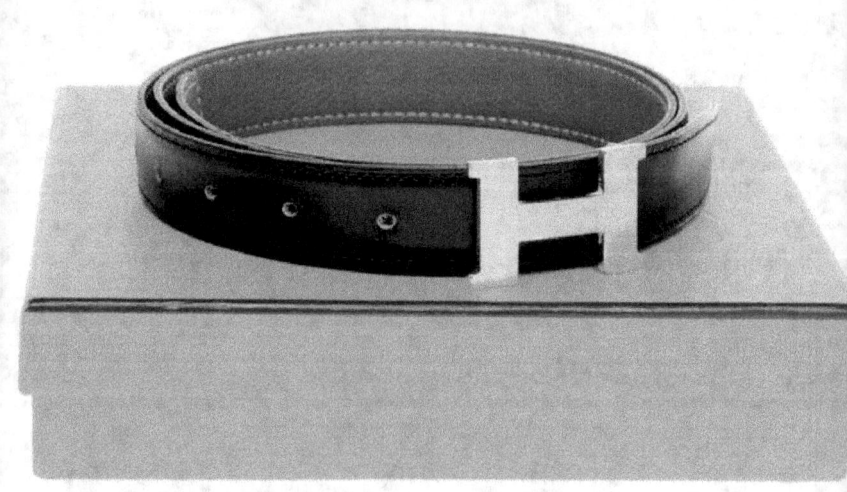

21

The iconic **"H" buckle design. Launched in the 1960s**, this buckle has become a distinct signature of the brand. Hermès has innovated by introducing a belt buckle that is not only functional, but also a very recognizable style element.

The "H" buckle can be interchanged with different belt straps, allowing customization to suit the wearer's tastes. This modular system, combined with the quality of the materials used, such as calfskin, ostrich or crocodile, makes it a very popular fashion accessory and a status symbol.

Charlotte Casiraghi, member of the royal family of Monaco and muse of Hermès. Passionate about horse riding, Charlotte has often been seen participating in equestrian competitions dressed in Hermès. This collaboration is particularly significant because it echoes the roots of the house of Hermès, which began as a manufacturer of high-quality harnesses and saddles. Charlotte Casiraghi's association with Hermès highlights not only her own equestrian heritage, but also the brand's ongoing commitment to the world of equestrianism.

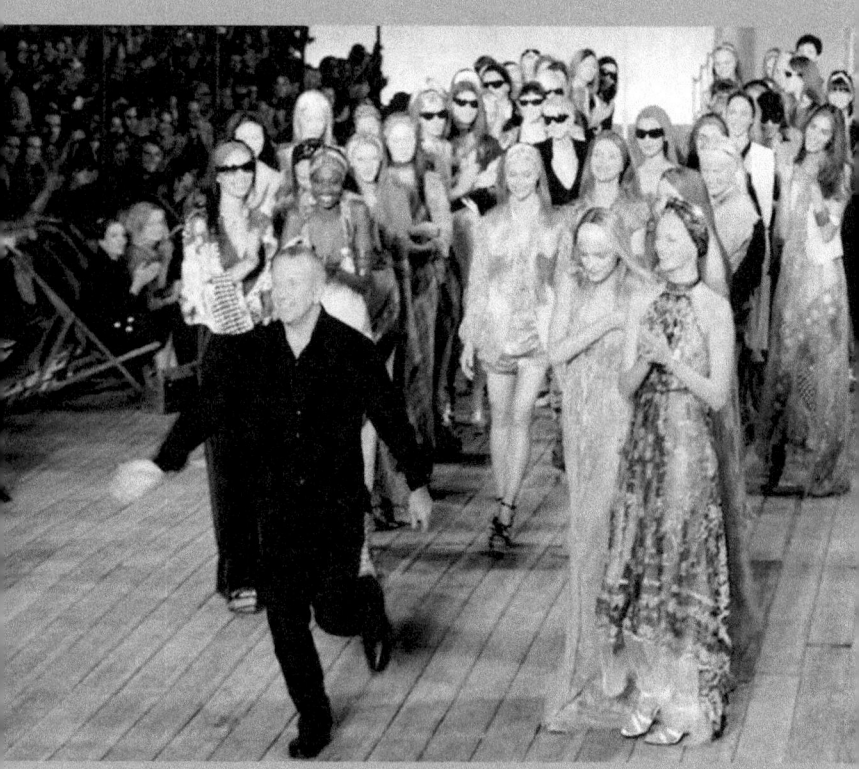

23

Jean Paul Gaultier – Although primarily known as a fashion designer, Gaultier served as artistic director for Hermès from 2003 to 2010, bringing his unique flair and creative vision to their ready-to-wear collections.

Jean Paul Gaultier, famous for his avant-garde and sometimes provocative approach to fashion, served as artistic director for Hermès from 2003 to 2010. This collaboration marked a significant period for both Gaultier and Hermès, as the designer brought his distinctive style to a house traditionally known for its understated elegance and refinement.

Gaultier has managed to infuse the classic spirit of the brand with a touch of modernity and rebellion, while respecting and promoting the high quality heritage of Hermès. His collections often included innovative interpretations of the brand's classics, blending Hermès' artisanal expertise with bolder, contemporary design elements.

Hermès fashion shows have often been highly anticipated events, revealing clothes that combined functionality and luxury. He introduced elements such as softer leathers, technical fabrics, and a bolder color palette, while retaining the impeccable cuts and attention to detail that are hallmarks of Hermès.

As well as revitalizing the women's and men's ready-to-wear lines, Gaultier has also brought his influence to other aspects of the house, such as accessories and leather goods, breathing new life into these ranges without ever compromise brand integrity.

The collaboration between Jean Paul Gaultier and Hermès is often seen as a successful marriage between tradition and modernity, having helped position Hermès as a brand capable of transcending eras while remaining faithful to its artisanal heritage.

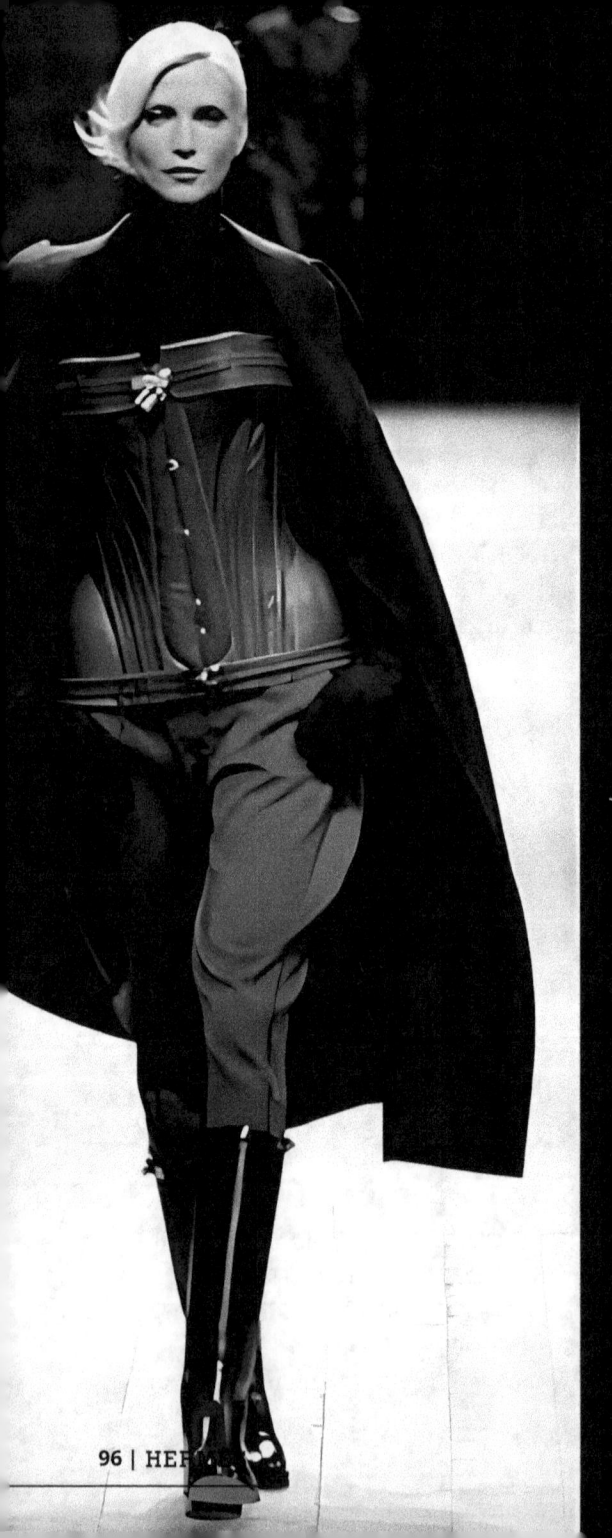

Jean-Paul Gaultier launched his collaboration with Hermès with the fall-winter 2004-2005 collection, naturally inspired by the equestrian world. In this collection, top model Nadja Auermann was notably dressed in a leather corset worn over a jodhpur.

Lou Doillon was also present during this memorable first Jean-Paul Gaultier fashion show for Hermès. Her participation added a special charm to the event, strengthening the alliance between haute couture fashion and contemporary style icons

Lou Doillon, known for her unique style and family heritage in the fashion world.

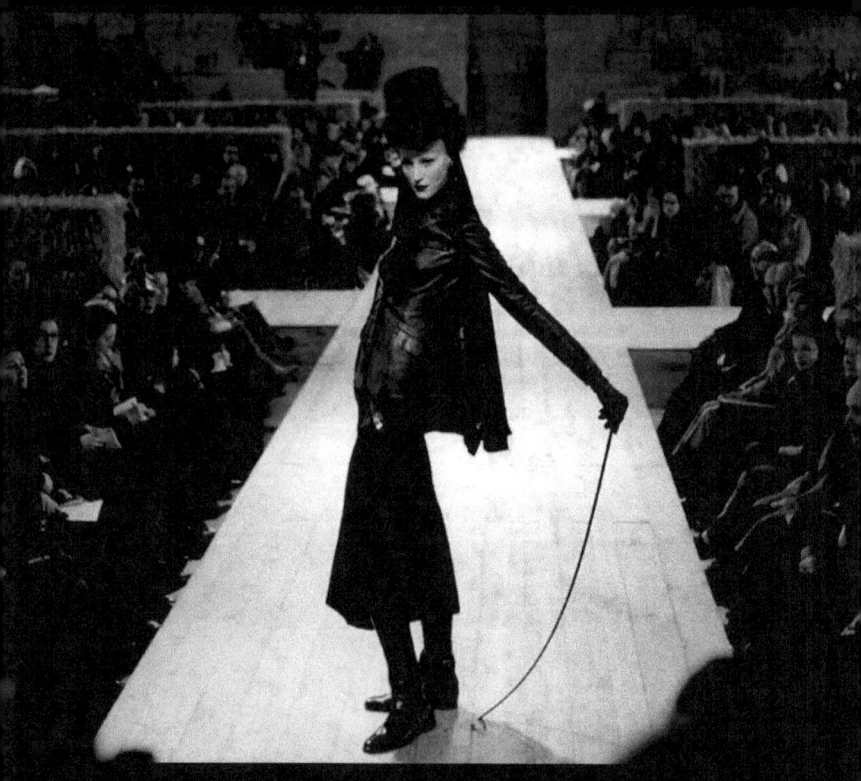

24

Jean-Paul Gaultier's collection for Hermès was marked by a literal interpretation of the equestrian theme, which charmed the audience in a unique setting dotted with hay bales. This scenographic detail was not only aesthetic but also symbolic, immersing spectators in a rustic atmosphere which echoed the equestrian heritage of the Hermès house. This framework reinforced the authenticity of the collection, showcasing the harmony between haute couture and the brand's traditional roots.

Inès de la Fressange, an emblematic figure of Parisian elegance, maintained a special relationship with Hermès, which helped to strengthen the brand's image of luxury and refinement. Her style, both chic and seemingly effortless, perfectly embodies the French elegance that Hermès wishes to project.

During the 1980s, Inès de la Fressange became one of the most recognized models in the world and was often seen wearing Hermès designs, both on the catwalk and in her personal life. Its ability to mix classicism with a modern touch fits well with the Hermès spirit, which values both tradition and innovation in its creations.

Inès has often been involved in events and advertising campaigns for Hermès, helping to assert the brand's positioning in the high-end fashion segment. His presence at brand events and personal adoption of Hermès products helped solidify the brand's image as a symbol of accessible and desirable luxury.

true incarnation of the Parisienne, a captivating blend of elegance, fantasy and daring, spans the ages with impressive natural ease. Star of this summer issue in Saint-Tropez, she reveals herself with a contagious joie de vivre.

Ines de la Fressange resumes her role as artistic director for her eponymous brand, created in 1991 by a holding company of the Louis Vuitton family. This year, the brand will experience a revival thanks to the investment of new funds. Calao Finance, a French investment fund, and The Luxury Fund from Dubai, also a shareholder of the luxury brand Elie Saab, acquired 30% of the capital.

moment

Invitée d'honneur

photoshoot
Ines de la Fressange

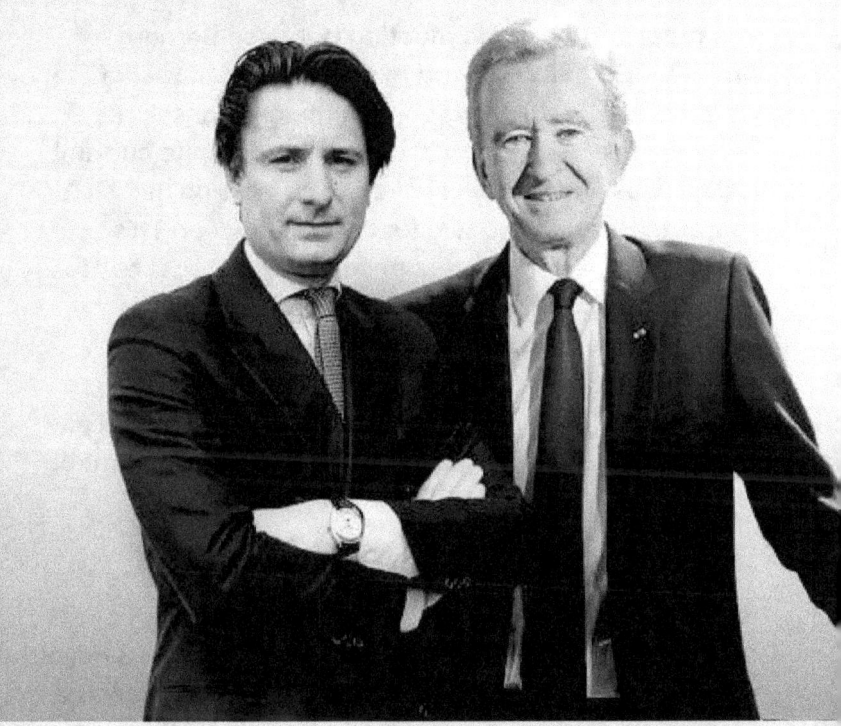

26

After 4 years of war, the world leader in luxury agrees to redistribute its 23.2% stake in the saddler to its shareholders.

The recent and historic meeting between Bernard Arnault, CEO of LVMH, and Axel Dumas, manager of Hermès, marks a turning point in the relationship between the two French luxury giants. Despite cultural differences and tensions linked to LVMH's ownership of shares in Hermès, the two leaders finally met. This meeting comes after years of conflict and legal battles between the families that own Hermès and LVMH. LVMH's ownership of 23.2% of Hermès fueled these tensions and was at the center of the debate. This meeting can potentially pave the way for a new era of cooperation or relaxation between the two emblematic French luxury houses.

The relationship between LVMH and Hermès dates back to 2010, when LVMH announced its acquisition of 23.2% of the capital of Hermès. This operation sparked a major controversy, because the Hermès family, which owns a large part of the company's shares, opposed this unsolicited participation by LVMH.

This hostile acquisition led to years of legal and financial conflict between the two luxury houses. The Hermès family has made significant efforts to protect its company from LVMH's claims, seeking to reduce the latter's stake in Hermès' capital.

Tensions persisted for years, with battles in courts and financial regulators. However, despite these differences, the two companies have remained major players in the French and global luxury sector.

The recent meeting between Bernard Arnault and Axel Dumas could indicate a desire for relaxation or resolution of differences between the two houses. It could also reflect a desire to find common ground or cooperation, despite cultural differences and past conflicts.

The Hermès family is both the history and the heart of the famous luxury house. Founded in 1837 by Thierry Hermès in Paris, the Hermès house has remained in the family since its beginnings. Here is some information on the key members of the Hermès family to date:

Thierry Hermès: Founder of the Hermès house in 1837, Thierry Hermès launched the company as a manufacturer of harnesses and saddles for horses. His attention to detail and commitment to quality laid the foundation for what would become an iconic luxury brand.

Charles-Émile Hermès: Son of Thierry Hermès, Charles-Émile Hermès succeeded his father at the head of the company. Under his leadership, Hermès expanded its product range to include luxury leather goods and accessories.

Émile Hermès: Grandson of Thierry Hermès, Émile Hermès was an important figure in the evolution of the Hermès house. Under his leadership, the brand continued to develop and innovate, notably by introducing the famous zipper on its products.

Robert Dumas: Son-in-law of Émile Hermès, Robert Dumas took the reins of the house of Hermès in 1951. Under his leadership, the brand expanded internationally and expanded its product range to include iconic accessories such as the Kelly bag and the Hermès square.

Jean-Louis Dumas: Grandson of Robert Dumas, Jean-Louis Dumas was president of Hermès from 1978 to 2006. He modernized the brand and positioned it as one of the leading luxury houses in the world.

Axel Dumas: Currently, Axel Dumas represents the sixth generation of the Hermès family to run the company. He was named co-CEO of Hermès in 2013, and since then, he has continued the brand's commitment to excellence and innovation while preserving family traditions and values.

This lineage of members of the Hermès family illustrates the importance of continuity and tradition in the long history of the brand.

The family business has so far been owned by Hermès heirs, one of the richest families in France. Since 2013, Hermès has been managed by Axel Dumas, a descendant of the founder. Its logo, since the 1950s, has been that of a horse pulling a chariot, an image which symbolizes the history of the brand.

HERMÈS
PARIS

"The ultimate elegance lies in the perfect harmony between the simplicity of lines and the subtlety of details, as Hermès celebrates through its creations."

Thierry Hermès

www.ingramcontent.com/pod-product-compliance
Lightning Source LLC
Chambersburg PA
CBHW052329220526
45472CB00001B/343